PHOTOGRAPHING
Children with Special Needs

A COMPLETE GUIDE FOR
PROFESSIONAL PORTRAIT
PHOTOGRAPHERS

Karen Dórame

AMHERST MEDIA, INC. ■ BUFFALO, NY

ACKNOWLEDGMENTS
Many grateful thanks to the very special children and their parents who have granted permission to share their photographs. The priceless examples of beautiful children in this publication provide inspiration and education to photographers worldwide. We are also indebted to the many devoted care providers who intimately know the needs of the disabled and seriously ill child and have shared their knowledge and experience. The guidance of these administrators, clinicians and staff members has provided invaluable information for this publication.

SPECIAL NOTE TO USERS OF THIS BOOK
The authors, reviewers, editors and publisher have made extensive efforts to ensure the information contained herein is accurate and is representative of conditions described at the time of publication. However, constant changes in information resulting from continuing research and practical experience, reasonable differences in opinions among professionals, unique aspects of individuals and situations and the possibility of human error in preparing such a text require that the reader exercise judgment when making decisions regarding the varying aspects and components of a photographic session. Always consult and compare information directly from the parent, care provider or other reliable sources

Front cover photo by Sally Harding (www.treasuredimage.com).
Back cover photograph by Dina Ivory.

Published by:
Amherst Media, Inc.
P.O. Box 586
Buffalo, N.Y. 14226
Fax: 716-874-4508
www.AmherstMedia.com

Publisher: Craig Alesse
Senior Editor/Production Manager: Michelle Perkins
Assistant Editor: Barbara A. Lynch-Johnt

ISBN: 1-58428-086-7
Library of Congress Control Number: 2002103399

Printed in Korea.
10 9 8 7 6 5 4 3 2 1

Dedication

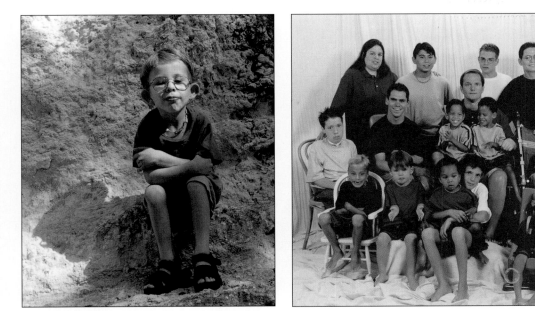

This book is dedicated to Taylor (left), whose mother had the vision to create the Picture ME Foundation, and to the James Silcock family (right). Anne and James Silcock have eighteen adopted boys (all with disabilities). (Silcock family photograph by The Picture People.)

TABLE OF CONTENTS

SECTION TWO—UNDERSTANDING CHILDREN'S CONDITIONS AND SYMPTOMS

SECTION THREE—SPECIAL TECHNIQUES AND RESOURCES

PREFACE

*T*HIS BOOK WAS CREATED OUT OF A MOTHER'S FRUSTRATION to secure a professional portrait of her one-year-old disabled son. These pages are dedicated to Taylor and also to the thousands of children like him who have some kind of disabling disease or disorder. Here's their story . . .

When our son Taylor approached his first birthday we wanted a studio portrait to show the progress he had made after a long year of multiple doctor visits, surgery and therapy for a rare connective tissue disorder. However, our celebration turned to shock and frustration when we were met with a photographer's insensitivity to our boy's differences in appearance and physical ability.

A truly beautiful photograph can positively impact self-worth and acceptance.

I went home feeling discouraged but assumed ours was an isolated experience. Unfortunately I soon discovered we were not alone in our frustration. After talking with other parents of children with disabilities, I learned they all had similar difficulties in attempting to obtain a professional photo of their child.

A truly beautiful photograph that captures a child's personality can positively impact self-worth and acceptance. In my heart I knew pictures would not cure a disability or disease, but could provide families with visual keepsakes of the immeasurable gift they have been given in their very special child.

—*Heidi Lewis*

INTRODUCTION

*H*AVING PROFESSIONAL PHOTOGRAPHS OF THEIR CHILD means as much to the parents of special needs children as is does to the parents of any other child. However, the parents of special needs children often encounter additional obstacles when looking for photographers who can create these family heirlooms.

SKILL, SENSITIVITY AND KNOWLEDGE

Speaking from their own experiences, the following comments are offered by parents, therapists, administrators and social workers to help enlighten photographers about the experiences of those who love and care for special needs children. As you read through these words, consider them an invitation to rise to an important challenge—to continue reading this book and to begin acquiring the added knowledge you need to provide skilled, sensitive service to each and every one of your clients.

> **Therapist.** "Families typically do not display photographs of their child with a disability or serious illness, primarily because many photographers do not have the skill, sensitivity, knowledge or interest to pursue this endeavor. Yet, with such a focus as offered in this book, this aspect of photography could produce a wonderful sense of satisfaction for all those participating in this endeavor: photographer, subject (child with illness or disability), family and friends."

> **Parent.** "We have not had professional pictures of our child taken in three years. Anytime we would take him

Facing Page—Joshua has a connective tissue disorder called Ehlers-Danlos syndrome, a symptom of which can be flat feet. But who notices the feet in this beautiful photo of a boy catching fish? Photograph by Donna Leicht.

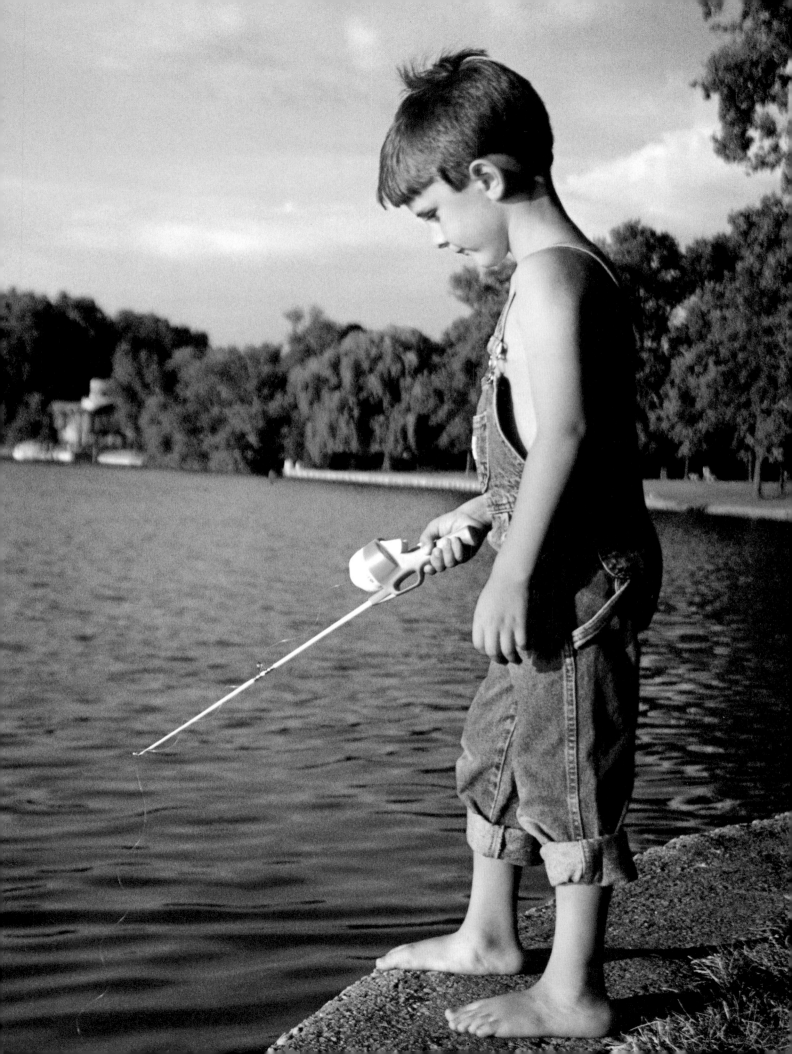

into a portrait studio, the employees would hover together trying to decide who had drawn the short straw."

Parent/Photographer. "I am the mother of a beautiful Down syndrome boy. I just started in this field of photography and am looking forward to helping professional photographers and families capture the spirit of these special kids."

Parent/Care Provider. "Even though a child may have an apparent disability, a photograph can be creatively and artistically produced which depicts natural features positively and attractively. Such an image can provide a tremendous boost to that child's self-esteem. These pleasant photographs are exhibited proudly and enjoyed by all who view them."

Physical Therapist. "A child who appears 'different' elicits attention from society—an issue for anyone with a disability, at any age. The more severe or apparent the disability, the more challenging that issue is to deal with (especially for children in the formative years when their sense of self-esteem is being developed). With that in mind, anything that can be a positive experience of 'self' is of great value for such a child."

Clinic Director. "Families with special needs children are just like any other family. They want photographic memories of their child's accomplishments. They want quality pictures that show how their child has grown and changed over the years. Yet many parents with special needs children do not have and display professional photographs because of the response they have gotten from photographers—simply because their child *can't* just sit, pose and be photographed. These parents want and need photographers who will spend a little extra time to get to know their child and his condition, and then make a few

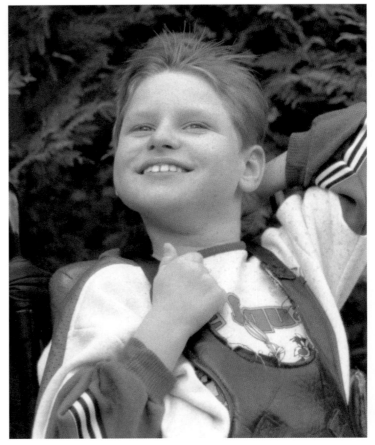

Timmy is a happy child. Unlike some other children with cerebral palsy, he will generally look directly at the photographer behind the lens—although not for this shot! It goes to show that lack eye contact doesn't have to make or break a photo.

simple modifications to ensure a quality photograph for the family album. This book will benefit not only the photographer but also the many families with special needs children."

OVERALL GOALS

It's all about communication, patience and understanding. When photographing children with special needs, you need to place photographic skill and technology *lower* on your list of priorities. Even though patience plays a key role, the ability to work flexibly and respond quickly are key operatives for success.

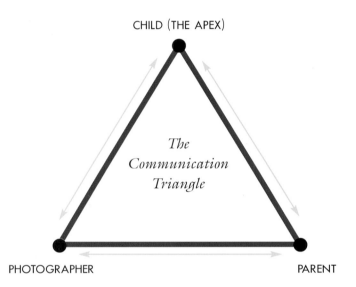

The photographer must communicate constantly with the parents and the child before and during the photo shoot. The parents are also expected to hold up their end of the communication triangle by making clear what they want from the photographer and by explaining the child's capabilities. It's important to communicate about these issues before the photo session begins.

Sometimes this type of session is more like a careful juggling act than a photo shoot. Most often, the photographer needs to be the anchor (or juggler) and provide stability for the interaction.

Let's look at the different points of view that the participants bring to the session:

The Child's Perspective. Praise the child. Compliment him. Comfort her. Do not talk down to the child. Understand the child's condition without "categorizing" him. A child may have multiple disabilities that all need to be taken into consideration. Get to know the child before the photo session by meeting him or her and interviewing the parent. Know what to expect; don't get caught by sur-

Sometimes this type of session is more like a careful juggling act than a photo shoot.

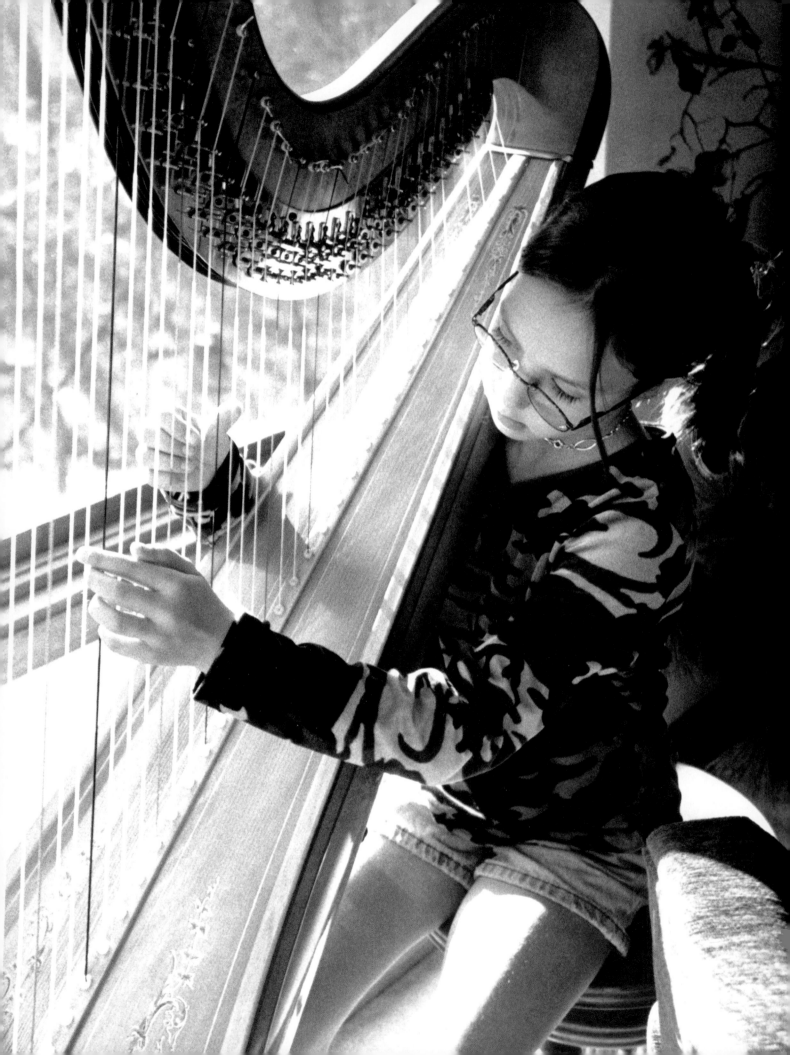

Facing Page—Sarah has Binder's syndrome, a condition affecting the nose and most often requiring surgery. Donna Leicht took this into consideration when creating this carefully lit and posed photograph—which also showcases Sarah's musical skills.

prise while the child is withering under the strain and "assault" of bright lights and strange noises.

The child may have ideas, too. If the child can communicate her wishes, listen to what she wants and consult with the parent about meeting the desire of the child. Knowledge brings understanding and confidence. Use your knowledge about each unique child to bend your photographic skills into a method that is tailor-made for that child. As a teenager with cerebral palsy once communicated to me, "I'm just like all other teenage girls. I want to be seen as beautiful, confident and happy."

The Photographer's Perspective. The photographer wants to create a beautiful portrait, a lovely pose, the beautiful smile and perfect posture. Lighting will need to be adjusted, time will be taken to focus and capture an image at just the right moment. After all, the studio walls are covered with beautiful "trophies" of happy, smiling children that have been captured on film. Bear in mind that the road to this end result may not be the path normally taken.

If you have not worked with many special needs children, you may experience some anxiety. To compensate, you may be tempted to "beef up" all the standard photographic tools of lighting, posing, expression and special backgrounds. In actuality, you'll have more success if you toss technique aside and just have fun by following the child around with a camera under natural or flat lighting.

The Parents' Perspective. The parents may also be nervous—they may have had a bad experience and be wary about repeating it; they may be unaccustomed to the photography process and environment, etc. Parents and photographers can help each other relax and achieve better results by sharing information. Parents should be open with the photographer about what can be expected during the session. Photographers, in turn, should explain how they work, the equipment they use and what to expect at the session. Everyone must try to be patient.

From the Photographers . . .

"The mom had taken him to professionals with studios and was frustrated because they expected him to sit down and look at the camera. They also took the lenses out of his glasses for the pictures, which she said made it look really fake. I talked with her about what she wanted—I then went to the home and spent time following him around and talking with him. I really like how the photos turned out."—*Teresa Nagy, professional photographer, on photographing a young boy with autism*

● What You Need to Know

Individual Abilities. It is often said that you have to learn the rules before you can break them. Accordingly, you can begin to understand the child's *individual capabilities* by educating yourself about their *general disability.*

Know that the parent may be on the defensive. A parent's "attitude" may actually be a reaction to a perceived problem in the way you are communicating or interacting with the child. A studio photographer with special needs experience relates the following experience: "Once, a frustrated photographer came to the back room and warned me about the mother. As a result of taking the Picture ME special kids photography workshop, and from my own experience with special needs kids, I knew that the mother just wanted someone to listen to her.

"I asked her about her son Jason—and the simple act of being interested in her child resulted in the tension melting from her face. She told me that even though he was six months old, he could not sit up yet. I told her that we wouldn't worry about what he *couldn't* do, we would focus on and work with what he *could* do.

"The baby was very tired, having already been through a sitting, waited around for an hour for the pictures to be processed, and then going

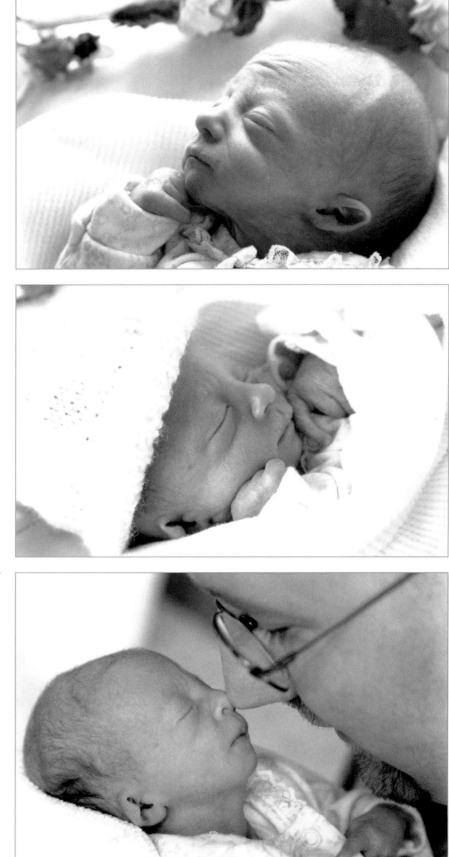

Facing Page and Right—Donna Leicht
created these delicate portraits of Ella,
a little girl with Trisomy-18.

through another sitting. But, given the circumstances, I got the best
out of him and the mom was very happy with the results."

Most often, you will not be able to coach a "smile on demand"
or create a predetermined pose. Some photographers are "driven" to
always obtain eye contact—and even this is not always possible with
the special needs child. One photographer, whose mind set represents
that of many photographers, commented on the subject of working

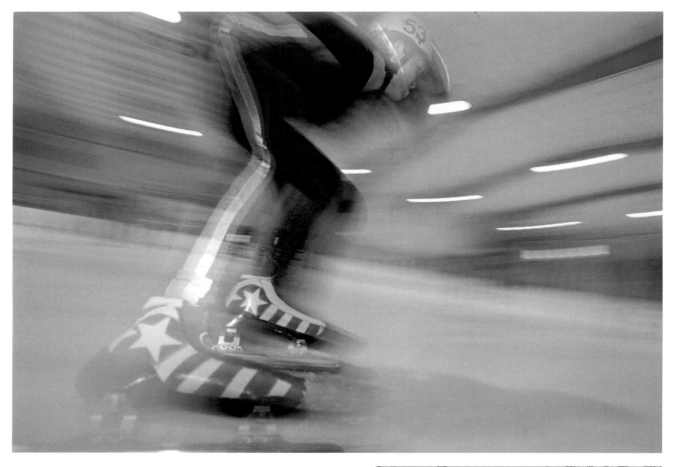

Above—As Bryan McLellan's high-action portrait of this speedskater shows, special needs children sometimes have some exceptional skills! (Los Angeles Times photo by Bryan McLellan)

Right—Angelman syndrome has caused weakness in Kyle's legs, but he enjoys the chance to travel the slopes in a bi-ski at the U.S. Adaptive Recreation Center at Big Bear, CA, where volunteers guide him down the runs. Here, he's shown with his brother.

with a special needs child, "I have been able to get a smile and eye contact out of every child that I have worked with in my twenty years as a professional photographer. If I can't get eye contact, I won't be able to get a good portrait. Oh, she can't smile or look at the camera? How am I expected to get a decent picture of this child? What will a parent do with a picture of a kid who is not happy? They don't want a sad picture!"

Movement. Prepare to take your camera off the tripod and follow the child around, catching photos "on the fly." Plan on using a lot more film than normal. As an example, a 35mm SLR camera may not provide the quality to which you are accustomed, but it will pro-

vide the flexibility you need to capture an image that will become an endearing keepsake.

Think ahead to have a bean bag available for the child who cannot sit and doesn't want his wheelchair to show. Make these options clear in the parents' pre-session interview. Listen to the parents; don't rush the interview. Let them know that you care and want to create a photograph of their child enjoying a moment in life. All parents want to have a visual trophy of their child for the wall of their home. No child is impossible to photograph—there is a beautiful image in *every* child. Your job is to find it.

Parents' Fears. The parent of a child with disability has been through years of interrogation about their child. Most often, they must endure stares, whispers and sometimes impolite, insensitive,

A colorful floral background sets the scene for this portrait in which Laura Popiel captures the special bond that Nicholas, a little boy with Down syndrome, shares with his sister.

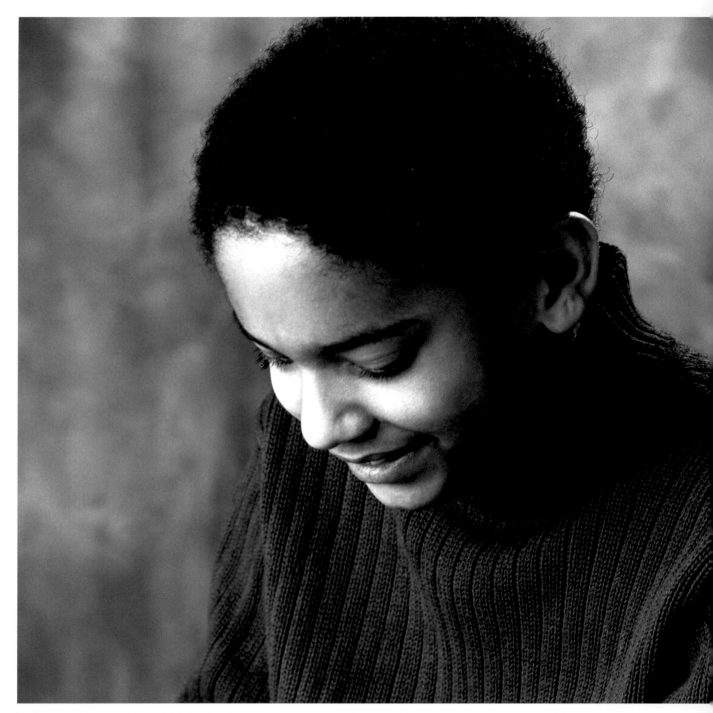

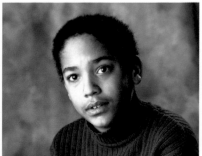

Above and Left—Flexibility is a must when photographing children with special needs, such as Bryan, who has autism. By staying on your toes, you can be ready to capture each unique moment. Photographs by Thomas Balsamo, who has photographed many children with autism.

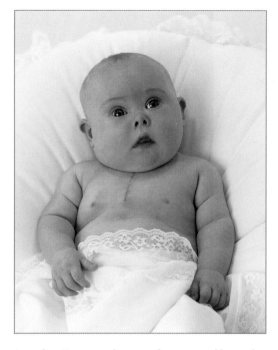

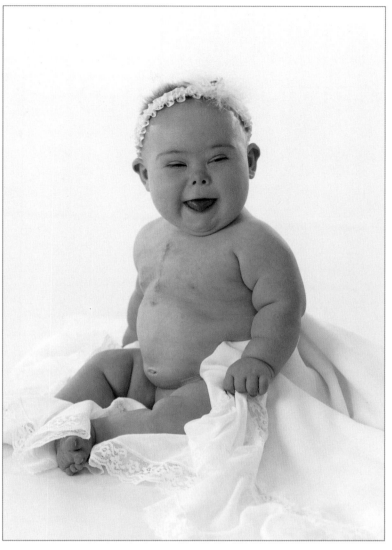

Jenna has Down syndrome and congenital heart disease. Above, she is shown at three months, and to the right she is shown at six months. In the image to the right, notice how the photographer has posed Jenna sitting up (not possible at three months) and thus reduced the appearance of the scar on her chest. Photograph by Dina Ivory.

barely heard comments. They know the beauty inside their child, but how do they get the person on the street to come to the same realization? Many parents don't even approach the professional portrait photographer for service, fearing humiliation or rejection.

Flexibility. Although the parents may think of the photographer as an "all-knowing professional," you may be intimidated when faced with a situation where actions and outcomes are somewhat unknown.

Professional photographers strive to produce a consistently high standard of quality. Many photographers have a signature style or technique and may be loathe to forfeit that "special look" by making adjustments to their favorite (or merely habitual) style of lighting, posing, etc. Achieving spectacular portraits of special needs children requires flexibility and spontaneity—but as a result of stepping outside of your comfort zone, you may also find that you are challenged to look at *all* of your subjects more creatively and with renewed enthusiasm.

Chapter 1

GETTING STARTED

*B*EFORE YOU BEGIN WORKING WITH SPECIAL NEEDS children, you'll want to consider how you can adapt your services and schedule to provide the best opportunity for great portraits. (Parents looking to hire a portrait photographer may also wish to keep these suggestions and guidelines in mind.)

EVALUATING YOUR READINESS

1. Is your studio lighting a floor-based or ceiling-based system?
A ceiling-based lighting system makes it much easier to maneuver a wheelchair or other assistive technology items.

2. Do you have large backdrops so you can photograph a child on the floor?
Some studio "chains" only do tabletop photography and aren't accustomed to accommodating a wheelchair.

3. Is the first appointment of the day available?
If you schedule your special needs clients as the first appointment of the day, there is little chance they will have to wait to have their photographs taken. Parents try to plan activities (like a portrait session) around their child's routine, and will find it frustrating if they have to wait a long time only to have the child exhausted before he or she even gets in front of the camera. If you book the client for an afternoon appointment and are running late, it is better to reschedule than to try to force good portraits out of a very tired child.

4. Are there some days or times that are less busy than others?
Try to book appointments with special needs children at times when

It is better to reschedule than to try to force good portraits out of a very tired child.

the studio is not overwhelmed with other clients. If the studio tends to be busiest on Friday, Saturday, Sunday or Monday, mid-week may be the best bet. Avoid the weeks before major picture-taking holidays like Christmas, Valentine's Day, Easter and Mother's or Father's Day. The weeks immediately following are often very slow and might be a good choice to avoid congestion.

5. How long are your photo sessions?

If you book twenty-minute appointments, don't expect to shoot four different outfits, some prop shots and other last minute additions. Let parents know not to expect this either. The goal of the session should be to create one great picture, without a lot of background changes. If the parents let you know that the child has very special needs, suggest allowing more time for the session.

6. Who is your best photographer?

If there are multiple photographers at your studio, let parents know who has the most experience with special needs children. Then, suggest that they make their appointment for a day when that person is working. This is not a type of session to turn over to an inexperienced photographer.

7. How can parents contribute to the success of the photo shoot?

Tell parents how they can help make the experience a more positive one. You may wish to remind the parent that, no matter how experienced you are, you don't know what *they* know about their child. Ask them about their child's special needs. Ask them if they notice things in your studio that they know will agitate their child (such as loud music), and address the problem. Ask if there is something special that makes the child smile.

Parents should keep calm; children will often pick up on their frustration. Encouraging the parents to take an active role in the session, and emphasizing that you welcome their input on how to work with their child, will help to calm their nerves.

If, despite all the efforts on everyone's part, things don't go well, discuss a re-shoot and invite the clients to come back another day. If the session seems to be growing very stressful, suggest that you cut it short so that the child doesn't gain a negative association with the process. There is no point in torturing the child, the parents or yourself.

Even if you don't get the results you hoped for, maintain a positive attitude about the process and make it positive for the child. On the child's return visit, you will have a greater chance of success if the child thinks that he or she had fun!

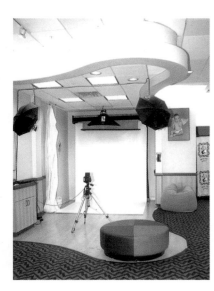

The Picture People professional portrait studio demonstrates a wonderful example of lights and other equipment hung from the ceiling so that the floor is clean and clear of cables, etc. The position of the seating platform is such that a child can access it without having to step around the camera and tripod. Photo by Sue Cassidy from The Picture People.

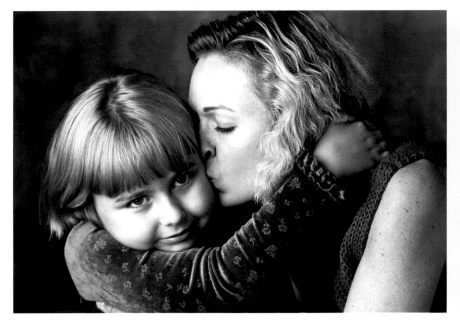

KEYS TO SUCCESS

This section contains suggestions from care providers and parents. Keep in mind that approaches to photography may vary with each disability, because children with the same disability may have a vastly different range of function—and some children have multiple disabilities. The key is to find their *abilities!* These pointers will help provide a more pleasant experience for all involved.

Additionally, you should not assume that the child does not understand you. Don't ignore the child, but go through these steps with each parent and child together.

1. Your primary photographic goals

Your goals should be to show the child experiencing life as he or she knows it, and to capture more than a smile; to reach the spirit of the child.

2. Pre-session interview

Interview the parent or caregiver on a day prior to the photo session. Use the Pre-Session Interview Questionnaire on page 31 or 32 to remind you of each of the areas that will contribute to a successful experience for all. The pre-session interview will be a major key to success!

3. Room preparation

Whether there is a wheelchair involved or not, clear a safe path for the child to enter the sitting area. Many children have supportive braces, or may try to reach out and grab a reflector or light stand along the way. If the parent is unsure about whether your equipment and the

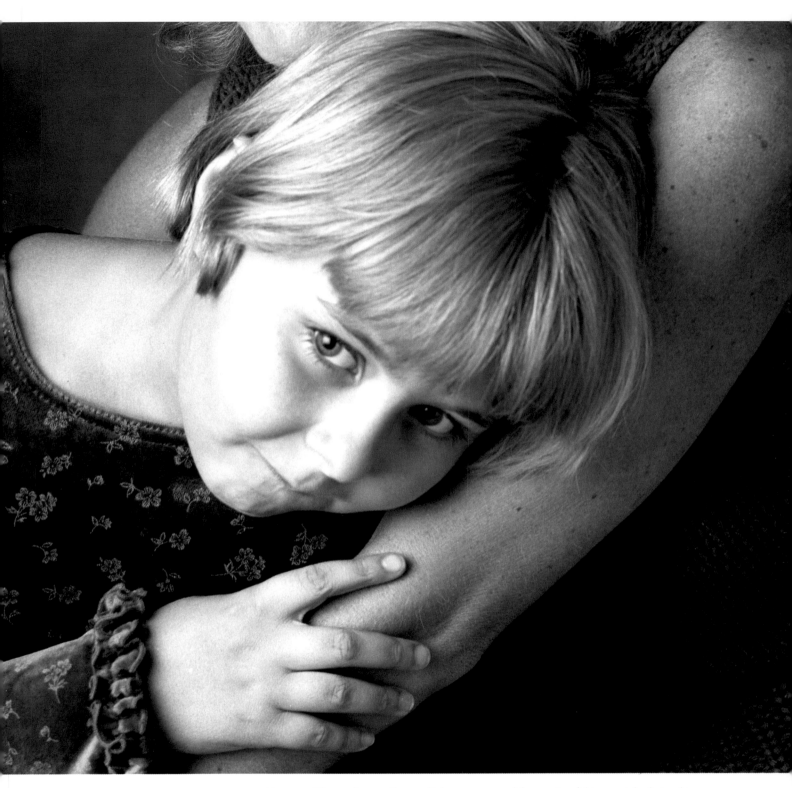

Above and Facing Page—Thomas Balsamo captured the magic of this special relationship in black & white, a clean and classic look that seems to emphasize the importance of the expressions and gestures. This subject of the photo is Stephanie, a little girl with autism.

"In the early '80s, a woman called me and explained that she had been to three professional photographers and had unsatisfactory results. Her two daughters, one of whom was autistic, had a very special bond. She wanted an image of the two of them that reflected their special connection with each other. Some photographers tried to force them into formal poses when what she really wanted was to capture some natural moments of her girls being together. She was disappointed that she did not have the images she wanted and asked me if I was the guy for the job. I eagerly said yes, but had no clue what I was getting myself into, because that was the first time I had ever been exposed to anyone with autism. I told her we would not be finished until we had created some images that contained the elements she was looking for. That experience was a turning point for me in my portrait career—the lessons I learned had an impact on my portrait style. The most important thing I learned was how valuable portraits could be when someone was willing to put so much effort into capturing a moment. As photographers, we need to realize the images we are creating can become the most valuable possessions of the subject's loved ones."—*Thomas Balsamo, professional photographer*

child will be safe in the same room, plan an outdoor shoot. Have a box of tissues and latex gloves nearby for emergencies.

4. No food
Do not have candy available in dishes or offer food as an incentive or treat. Remains of food or drink (cups, plates, etc.) should also be removed from the area. Stickers make excellent rewards. Whenever you consider offering a treat, ask the parent for their permission *before* handing out items to a child.

5. Meeting and preparing the child
Don't assume anything. Each child is different and unique. Two children with the same disability may have a vast difference in their level of function. One child who has cerebral palsy, for instance, may be able to communicate and interact on a high level, while another may not be able to communicate in a way that is clear to you.

Two children with the same disability may have a vast difference in their level of function.

6. Communication
Communication is important. Although each child may have his or her own special way to communicate, begin with the premise that the child understands you. If communication is at a lower level, try your best to make your instructions clear, but don't expect an answer.

Sarah's condition affects her nose. The beautiful flowers and lovely smile draw attention from the nose in this portrait. Photograph by Donna Leicht.

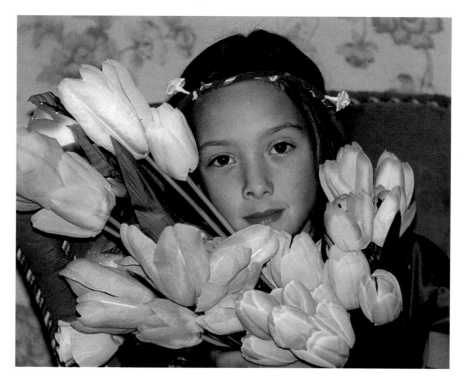

7. Addressing the child

Explain to the child what you will be doing. Ask or alert the child before you attempt any interaction with him or prior to moving into a different phase of the photo shoot. Speak directly to the child first, then approach the parent if you do not get a response. Repeat this process for each question and don't abandon your interaction with the child.

8. Engaging the child

Engage the child in the process—show them the equipment and perhaps allow the child to explore (under close supervision). Depending on the child, you could have a "retired" camera on a tripod or just available for inspection by—and interaction with—the child.

9. Choices

Offer choices such as, "Would you like a picture of you sitting in your wheelchair, or in the wing-back chair?" (Stand near and gesture toward the chair.) "Would you like to hold the ball or the fire truck?" (Hold one in each hand and move it forward when offering the choice.)

10. When the child is facing the camera

Lose your tendency to become embarrassed. If the child is unintentionally blowing bubbles from his mouth, let him know you are going to wipe them off. If appropriate, say, "Wow! What a great bub-

ble!" And then remove it with the swipe of a tissue. Sometimes people become embarrassed after, for example, saying something like "You see . . ." around a blind child. Don't make a big deal out of it if you find yourself in this situation, just move on. Blind children generally realize that people say "you see" as a part of common speech.

11. Eye contact

Don't insist on a smile and eye contact. In many instances, children with special needs do not respond well to such prompts. Better results may be achieved by using a gentle and caring attitude to create a reason for them to smile. Some children are able to smile, but the parent knows the best "triggers" to use in extracting certain responses.

12. Have fun!

Get to know these special kids! Some photo shoots with special children are best accomplished without a tripod and with natural lighting, eliminating the need to set up special lighting or struggle to create "just the right pose." As a result, the session may be more relaxed and even take less time than would a session with a child without disability—so, enjoy the experience. You and the parent and child will all thrill at the discovery of the beautiful images after they have been created.

From the Photographers . . .

"Even with their disabilities, parents would like the best for and from their child—and that includes a good photograph to keep or send to the relatives."—*Keith Wyner, photographer and teacher of special needs children*

Nickolas, who has cerebral palsy, was photographed with his family by Dina Ivory.

THE PRE-SESSION INTERVIEW

*T*HE PRE-SESSION INTERVIEW IS A CRITICAL KEY TO success—its importance cannot be overstated. Many special needs children do not fall under any one specific diagnosis. In fact, most of them have multiple disabilities. Even within any one diagnosis, there is a broad range of involvement, which means a varied range of function and ability.

Be sensitive to the parent and the child during the interview. Get to know the parent first. As with any child, if the youngster sees you as a friend of the parent, you are more likely to be trusted.

Ryan is constantly on the move, but obliges the photographer with eye contact and a smile.

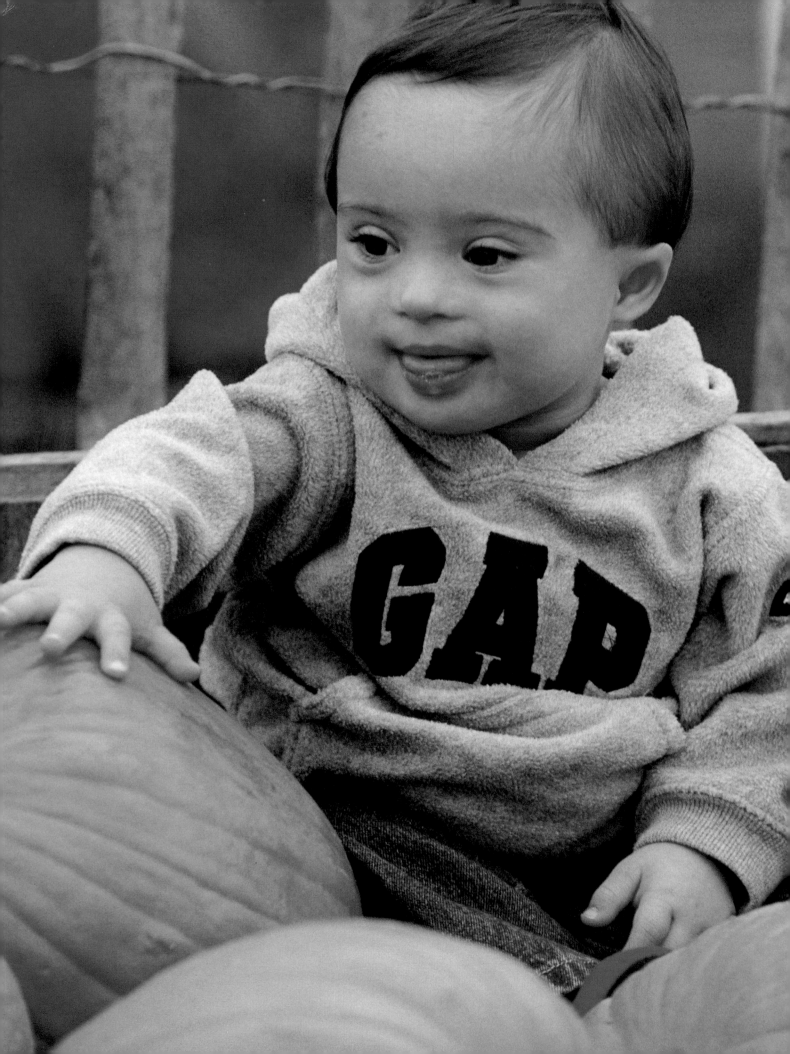

Above—The pre-session interview allows you to develop a rapport with both the parent and the child so you'll know what kind of images to plan on doing. Vickie loves to get dressed up and have her photo taken. Although she can sit fairly still, cerebral palsy limits her ability to follow directives to pose in a certain way.

Facing Page—Laura Popiel captured Nicholas, a boy with Down syndrome, looking quite happy to be in this rustic setting.

SETTING THE TONE

Most parents have endured years of questioning about their child, so be prepared for them to instinctively regard this—at least initially—as one more invasion. If this is the case, you may wish to gently suggest to the parent that you are a type of care provider and need to know critical information prior to providing your service. You should always approach the interview in a conversational way, rather than running through a list of clinical questions. Once the parent sees that you really care, she will relax and welcome you—and probably even volunteer answers to many questions before they are asked. If the parent still seems to resist your queries, do the best you can with the information available.

RAPPORT AND ABILITIES

The primary purpose of the interview is to establish rapport with both the parent and the child. Following that, your review of the child's condition will help you ascertain his physical and cognitive state, method of communication, level of response and any other critical information helpful for a photo shoot.

Can the child sit unassisted? Hold her head up? Does he understand and respond to directions? Does the child like to be touched by strangers? The answers to these questions illustrate why children with disabilities are viewed as having "special needs."

ADVANTAGES OF A FACE-TO-FACE MEETING

These questions can be asked on the phone if absolutely necessary, but you will gain so much more insight if you interview the parent and meet the child in person—especially if you can meet them at home. On home turf, a parent is more likely to be relaxed and may offer tidbits that you would never have thought to ask.

If the photo session is planned for the studio, you should invite the child and parents in for an interview and tour so that you can

From the Photographers . . .

"There is a great need for photographers to develop the ability to capture images of these children in a way that will create lasting images for their loved ones. In my opinion, the greatest reward is when I am able to make an emotional connection with these kids. They all are important and deserve the same love and respect as any other child."—*Thomas Balsamo, professional photographer*

begin to ease the child's anxiety. Whether at home or in the studio, just seeing the child in advance offers many advantages for the photographer. No matter which method of pre-session interview you choose, encourage the parent to prepare the child a few days prior by building up the photo experience as a fun activity. Then follow through and meet that expectation!

Most parents will appreciate your going the "extra mile," and open their heart to you. The process is extremely rewarding and also gives you the understanding necessary to capture the true spirit and personality of each child.

A pre-session interview allows you to evaluate the child's needs and abilities so that you can plan the best shoot for that individual.

RESPECT

Above all, when meeting the special needs child for the first time, treat him or her with the respect that is relative to that child's age. Assume that the child understands everything you say, unless you find out otherwise. Disabled kids are like typical children in many ways—they have individual personalities and feelings. Don't make the mistake of thinking just because a child can't talk, sit or respond, they don't understand. These are wonderful kids, dearly loved by those who know them. It's up to the photographer to take the time and effort necessary to capture and preserve the essence of each special child.

FORMS

Feel free to photocopy (or adapt) the forms on the following two pages. These two forms will remind you of the specific information that should be covered and can be referred to quickly to refresh your memory as you plan for the shoot.

PRE-SESSION INTERVIEW QUESTIONS (WRITTEN STYLE)

Child's Name:_____ Age: _____ Parent(s): _____

Address:_____

Phone:_____ E-mail:_____

Interview Appointment: (consider best time of day for the child's condition)

Interview date/time:_____ Session date/time:_____

Location:_____

Directions:_____

What "image" do you see for your child's portrait?_____

About the Child:

Condition:_____

Does the child understand what is being said?_____ Responds when spoken to_____

How?_____

Follows directions?_____

Vision ability:_____ Eye contact possible?_____

Hearing ability:_____

Is the child affectionate?_____ Touch OK?_____ Hugs OK?_____

Can the child talk?_____ If not, how does he/she communicate? _____

To what extent can the child use his/her hands?_____

Child uses a wheelchair?_____ Transfers?_____ Sits unassisted?_____

Stands?_____ Uses walker?_____ Uses braces?_____

Other assistive devices or breathing/eating technology?_____

What scares, upsets or angers the child?_____

What gets a positive response?_____

Interests or likes:_____

Where is the child comfortable?_____ Home?_____ Outdoors?_____ Studio?_____

Other?_____

Parent to bring music?_____ Use what type of music?_____

Would a studio or flashing/flickering lights bother him/her? _____

Optically triggered seizures?_____ Other seizures?_____

Tires easily?_____ Best at what time of day?_____

How does he/she react to strangers?_____

Change in routine?_____

Other sensitivities to sounds, smells, allergens?_____

What other behaviors, etc., should we be alerted to?_____

Other helpful hints:_____

Notes:_____

PRE-SESSION INTERVIEW QUESTIONS (CHECK-BOX STYLE)

Child's Name:_____ Age:_____ Parent(s):_____

Address:_____ Child's condition:_____

Phone:_____ E-mail:_____

Appointment:

Pre-sitting interview time/date:_____ Sitting time/date:_____ Time allowed:_____

Location:_____

Directions:_____

Check List:

Ask the parent (and if possible, include the child's wishes):

What "image" do you see for your child's portrait?_____

Reaction to strangers:_____

What frightens the child:_____

What gets a positive response?_____

Interests or likes:_____

Other:_____

Check one or more items in the groupings below. Use back of form if additional space is needed.

DISABILITY (one or more)
- ☐ Cognitive
- ☐ Mental
- ☐ Physical
- ☐ Sensory
- ☐ Medical

LIGHTING
- ☐ Natural light best
- ☐ Subject to seizures
- ☐ NO flash
- ☐ Flickers cause seizures

SOUNDS
- ☐ Likes music
 Type:_____
- ☐ Does not like sudden sounds
 or abrupt changes
- ☐ Does not like loud sounds

COMMUNICATION
- ☐ Child understands you
- ☐ Responds to questions
- ☐ Can follow directions
- ☐ Talks. How communicates?_____

PREFERRED LOCATION
- ☐ Studio
- ☐ Home
- ☐ Location
- ☐ School

SEATING
- ☐ Sits unassisted
- ☐ Beanbag OK
- ☐ Bench
- ☐ Stool
- ☐ Chair with arms
- ☐ Wheelchair

PHYSICAL ASPECTS
- ☐ Mobile
- ☐ Sits OK
- ☐ Wheelchair
 - ☐ Transfers alone
 - ☐ Assisted transfers only
- ☐ Assistive technology
 Type:_____
- ☐ Breathing tube (trach)
- ☐ Nose prongs
- ☐ Medical appliance
- ☐ OK to show assistive equipment
- ☐ Can use hands
- ☐ Subject to seizures
- ☐ Sensitive to touch

OTHER THINGS TO CONSIDER
- ☐ Allergy?_____
- ☐ Attention-getter_____
- ☐ Prop_____
- ☐ Tires easily
- ☐ Frequent tantrums
- ☐ Guard against possible infection

Parent will bring:_____

PHOTOGRAPHIC CONSIDERATIONS

*E*ACH OF THE FOLLOWING CATEGORIES ARE INDIVIDUALLY discussed, as they pertain to certain disabilities, in section two. Your considerations will vary for different disabilities. Some set-ups may differ from your usual methods, but that's the name of the game—it's why this book was written, and why it needs to be studied by professional photographers.

LIGHTING

1. Natural indoor or outdoor lighting will most likely be a major consideration with a child who is unable to adjust well to a studio.
2. Flat lighting may be your best solution for a moving child in the studio.
3. Shadows will work in your favor for a child with facial abnormalities or amputation.
4. Diffused sun and filtered light will produce excellent results.
5. Some types of lighting effects, and the equipment itself, can frighten a child.
6. Flickering light (including sun/shadow/sun) could trigger a seizure.
7. New lights that emit smoke or are still in the "burning off" stage could cause odors that can be hazardous to the health of a child with allergic sensitivities.

CAMERA

1. Consider using a handheld camera for a child who is constantly on the move (including those in wheelchairs), or even for following a child who is engaged in an activity that is of special interest to him or her.
2. Sometimes the camera (or photographer) can be very intimidating to a child. If this is the case, try putting the camera behind a type

Flat lighting may be your best solution for a moving child in the studio.

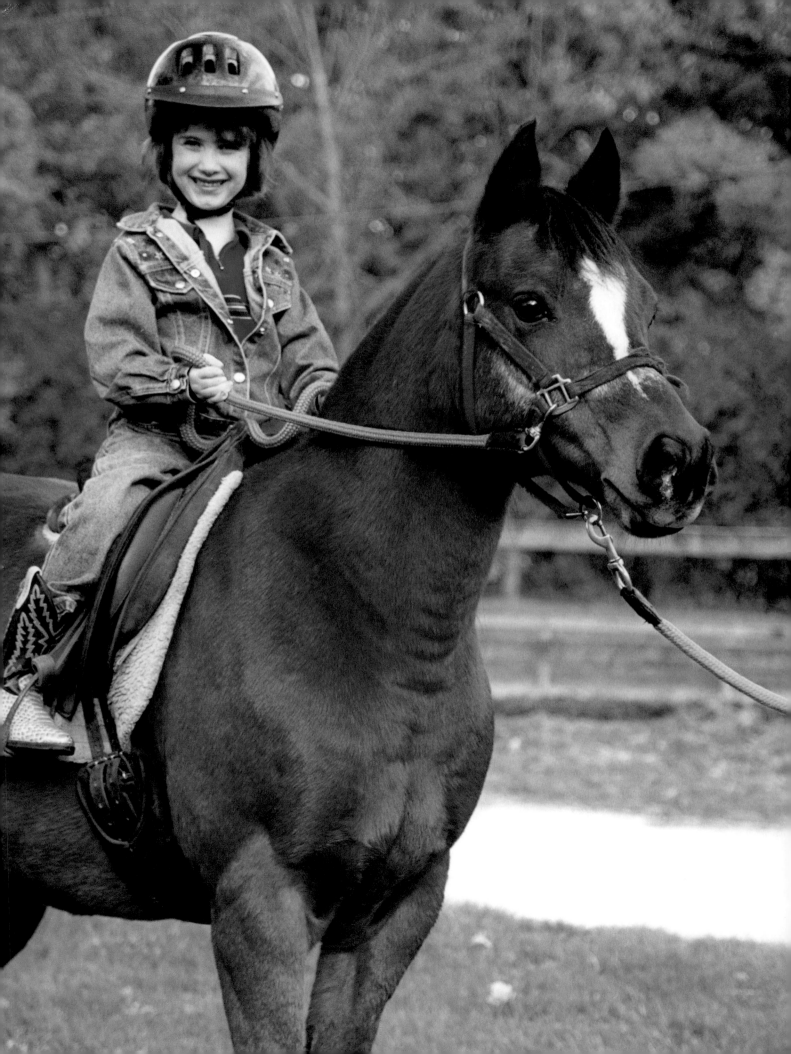

of concealment (but provide an opening for the lens, of course). For instance, a scrim setup can easily be constructed by using drape-like, painted scrim material (or loosely woven gauze) to conceal you (but not the lens) from the child. You can also fit the lens of your camera through a round opening cut out of a poster-board or a piece of foam core that has been painted with an image (see baffle ideas on page 108).

TRIPOD

1. Don't plan on using a tripod unless you are absolutely certain that it is appropriate for the child with special needs with whom you will be working.
2. A tripod is static and tends to lend a static quality to your photo. The parent of a child in a wheelchair may want to see as much movement as possible in the image of their child. (We are not talking out of focus movement here; the body language in a photo can be enough to suggest movement to the viewer.)

Like Johnny, who has Down syndrome, many special needs children are very active. Donna Leicht captured these natural portraits of the little boy.

FILM

1. When using natural lighting, higher speed film is going to be a major consideration. Of course, the grain of the film may be more apparent. Nevertheless, grain can be good. Grain can produce great results with certain shots, but grain in a straight-on, close-up, studio-type head shot may not produce the results you are looking for.
2. A speed of 1600 ISO will produce acceptable results in natural light. The grain with higher speed films can be overwhelming.

"Images that we capture rather than force are the most successful. When we set up a relaxed environment for children to feel comfortable in, we greatly improve our results. We must let them be themselves, but also try to connect by giving them our full attention. If you truly care about your subjects and have high expectations for the outcomes, the quality of your work will surely reach a new level."—*Thomas Balsamo, professional photographer*

3. Work with the processing lab on special grain results.

4. Be sure to experiment on your own time. Be confident with the results before using a new approach with someone's special child.

5. Consider using Polaroid positive film and special processing to produce interesting effects.

SEATING

1. Be sure to discuss seating with the parent or child prior to your photo session. Some parents or children may want to conceal any assistive technology such as a wheelchair, braces, or even a tracheotomy tube protruding from the throat—but not always.

2. If in a therapy room with many other disabled children, achieve elevation and angle down to the floor to avoid photographing as much equipment and tubes as possible.

3. Consider using a beanbag chair for non-ambulatory children. If the parents have a transportable seating arrangement at home, ask if they can bring it to the studio (or consider photographing in their home).

4. Alternate seating includes inflatable plastic "arm chairs" for children, the floor, a step, the arms of a sibling or parent, grandparent or friend—use your imagination and ingenuity.

Be sure to discuss seating with the parent or child prior to your photo session.

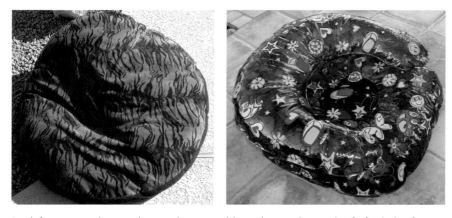

Look for seating devices that are low, portable and versatile—and safe for kids of many ages and abilities. On the left is a beanbag chair, and on the right is an inflatable chair.

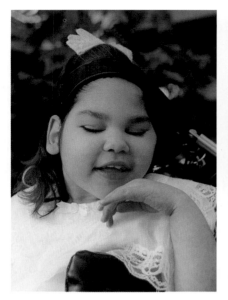

Specific, controlled, sustained posing is most often not possible with a special needs child. With this in mind, Jessica, who has cerebral palsy, was photographed outdoors in the natural light under a patio arbor. The photo on the left shows a head brace. When this is removed, her head is allowed to fall (center photo). In the photo on the right, the camera captures a momentary backward movement.

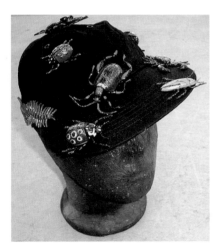

Simple devices, like this hat covered with glimmering plastic bugs, can be helpful for attracting the child's attention.

POSE

1. Specific, controlled, sustained posing is most often not possible with a special child. You will only get frustrated trying to get a specific pose out of a child with low cognitive function, autism, or limited muscle control.

DRAPE/BACKGROUND

1. Acquire and use a giant drape that can extend well over the background and floor. A child may be more comfortable on her tummy and elbows, side or back.
2. Try using a lightweight fabric that is easy for a caregiver to hold from behind while providing support for the child.

ATTENTION-GETTERS

1. What works for one special needs child may traumatize another and put an abrupt end to your photo shoot on that day (or even forever).
2. Ask the parent about sounds or lights that might be just as alarming to some children as something out of a horror film (whereas bugs and animals could delight the child).
3. When meeting the child prior to the photo session, experiment with various devices to get the child's attention.
4. Ask the parent about certain words or objects that will attract or calm the child. To some low function children, the sound of certain unique words will send them into delightful peals of laughter.

PROPS

1. Children can form attachments to certain objects such as a wooden doorstop or a piece of ribbon. The parent may enjoy having a

photo showing the child with his favorite giant paper clip. Another child may not want to part with his "comfort" object—which could be as simple as a lid from a coffee can. Do not try to remove these objects from the child unless the parent suggests it. Assess the situation and make a decision; don't act in haste.

2. Some children are unable to hold certain objects or may have the inclination to propel them across the room. Your choice of props (or no props at all) can be determined in the parent interview, long before the shoot.

CHILD'S FOCUS

1. As an experienced photographer, your first inclination—when you look through the lens—is to obtain the child's eye contact. Some

Possible props for a portrait include a favorite family pet or a treasured stuffed animal. (Note: Avoid passing stuffed animals from child to child as they can cary germs with them. It is better to have each child bring his or her own toy, if posing with a stuffed animal is desired.) Photographs by Theresa Nagy.

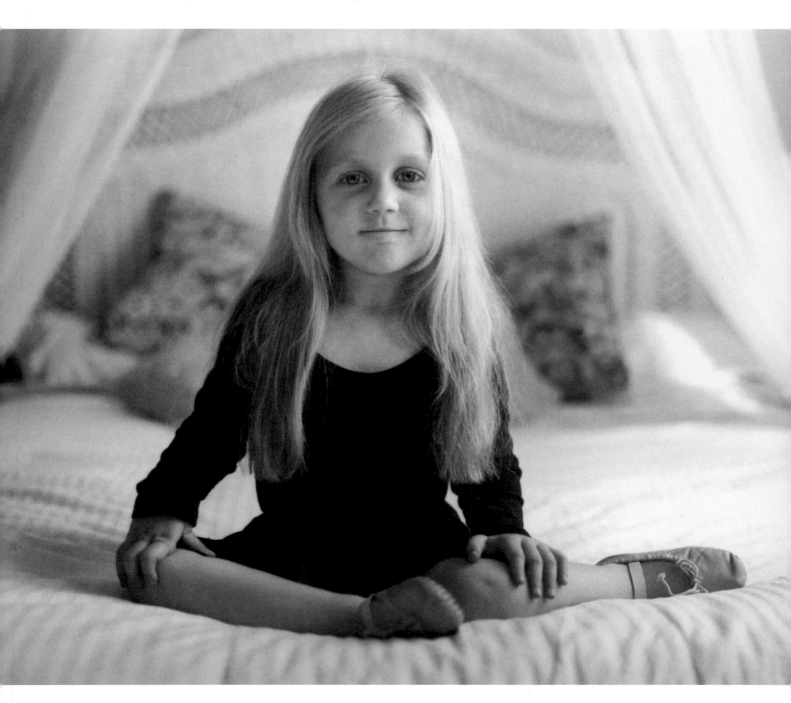

Amelia is a bright and beautiful girl who loves ballet. She has SMA (spinal muscle atrophy), a condition that causes progressive muscle weakness and wasting. Photograph by Carolyn Sherer.

children avoid eye contact, others seek it. Use the parent or assistant to attract the child's attention.

2. Some children (those with autism, for example) will purposely turn their head in another direction when they see a camera or when someone talks directly to them.

3. Children with visual impairments may not have a straightforward focus. Capture some images of them looking down or away from the camera. Eye contact is not a hard and fast rule.

Turn to page 123 for a quick-reference summary of these considerations that you can photocopy and keep with you!

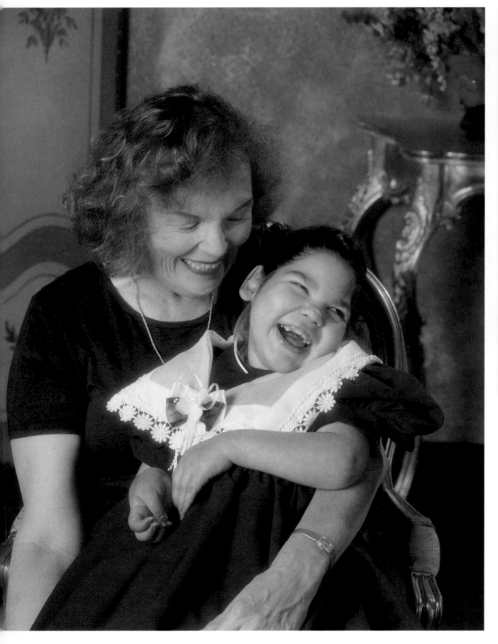

Left—Be prepared for the fact that some children may not be able to focus on the lens. Photograph by Anthony Wang.

Above—Timmy has cerebral palsy, but takes great delight in eye contact and posing (between unpredictable muscle movements that accompany the condition). Photo by Sally Harding.

Chapter 4

AMPUTATION

*T*HIS CATEGORY INCLUDES CHILDREN WHO ARE CONGENITAL amputees (born with partial or missing limbs) and those who have lost limbs due to injury or illness. Discuss the condition with tact and compassion. How would the child like to be posed? How would the parent prefer it? Work out the ideal solution between all parties.

ROOM PREPARATION
Learn if the child is in a wheelchair or walking on an artificial limb. If so, take extra precaution to remove cords, mats, or other objects that could obstruct access.

SEATING PREPARATION
Carefully discuss seating arrangements with the parent. Depending on the amputation, consider using a chair with side arms to aid the child in balance and getting seated. Provide ideas and solutions. For instance, if legs are amputated, discuss leaning over a "fence" or "hill." If the child or parent wants a full body shot, but without drawing attention to the arms, experiment with other poses—for example, you might photograph a boy sitting on the floor with his legs propping up a large book and his face appearing over the top of the book as if he were reading it.

WHAT TO EXPECT DURING A PHOTO SESSION
The greatest consideration should be given to the best way to include a wheelchair, prosthesis or other assistive devices, or ways to photograph the child with other means of support.

How would the child

like to be posed?

How would the

}parent prefer it?

COGNITIVE OR PHYSICAL CONSIDERATIONS

If the child has a prosthesis, they may or may not want it included in the photo. Accept the parent's or child's suggestions—even when humor is involved. Do not be surprised at a request to have a photo showing "amazing feats" of derring-do with a detachable arm or leg.

AGE CONSIDERATION

An older child could be more sensitive about an amputation than a younger child.

THE PHOTO SESSION

Location

No specific recommendation.

Greeting/Approach

Extend your hand for shaking as you normally would. If the child has no hands or arms, you may shake the part or shoulder they appear to be extending to you. If you are unsure, ask the parent ahead of time how they prefer to be greeted.

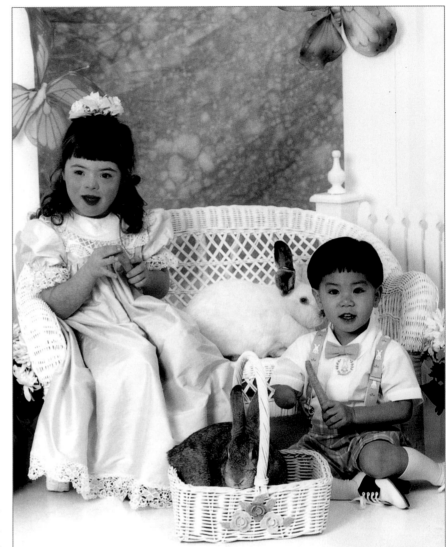

Here, the boy's amputated limb is visible, but hardly the main focus of the viewer's attention. Photograph by Jerry Costanzo.

Lighting

No special lighting consideration necessary.

Sounds

Music is usually fun for kids.

Attention-Getter

No special considerations necessary. Use good taste.

Props

Even if a child appears unable to hold an item, don't assume anything. Ask if any props are preferred for inclusion in the photo. Ask about action shots. Some children may want to be photographed rid-

ing a bike, even though they have only one arm. A photo showing physical ability will be proudly displayed on the family's gallery wall. Asking the child to make some decisions is empowering for them.

Posing
Ask if there are preferences for posing. Discuss the idea of creating a partial or full torso image.

Sitter's Focus
No special consideration necessary. However, the parent or child may want to conceal the amputation or prefer to direct the portrait viewer's attention away from the amputated limb.

○ SPECIAL CONSIDERATIONS
If the family does not want a traditional portrait, think out of the box. Offer suggestions that could build on the child's outstanding abilities. Show them at the computer. Show them drawing with their feet (if that is one of their talents). Ask about their interests so you can show them engaged in activities that will build their self-esteem. Provide them with photos that will be "trophies" to show to friends and family.

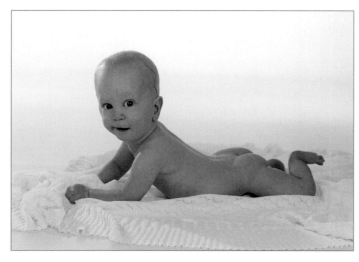

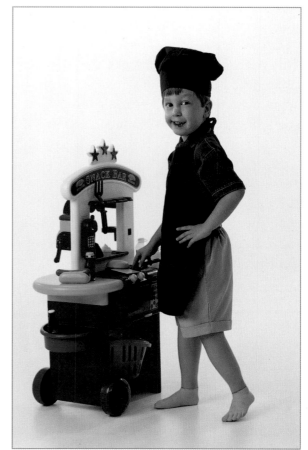

Adam had cranial anomalies from birth (above and right). In the later photo (far right) you can see that he has bilateral prosthetic legs. The chef's hat helps to conceal his cranial anomalies. Photographs by Dina Ivory.

Chapter 5

ATTENTION DEFICIT DISORDER (ADD) *and* ATTENTION DEFICIT HYPERACTIVITY DISORDER (ADHD)

C HILDREN WITH ATTENTION DEFICIT DISORDER HAVE POOR or short attention spans and impulsive behaviors that may be inappropriate. Hyperactivity may or may not be present. Estimates indicate that ADD affects 5–10 percent of school-aged children, with boys being diagnosed ten times more often than girls. Many of these children will do well in a photo session. More significantly involved kids will be helped by these suggestions.

ROOM PREPARATION

This child may have difficulty not touching things. Keep valuable equipment and lights out of reach. Do not leave a child with ADHD unattended while you position yourself behind the lens—by the time you look through the viewfinder, you may see a vacant chair!

Do not leave a child with ADHD unattended while you position yourself behind the lens . . .

SEATING PREPARATION

Discuss with parents the best type of seat for this child. If the child has a favorite stool or chair, ask the parent to bring it along. The child's legs or arms may be in constant motion. If the child is known to have difficulty sitting in one place for very long, invite the parent to help with keeping the child on the chair or stool.

WHAT TO EXPECT DURING A PHOTO SESSION

This child may be hyperactive, withdrawn, shy or aggressive. Consult with the parent for clues to possible expected behavior. Make it a priority to plan behavioral strategies with the parent beforehand.

COGNITIVE OR PHYSICAL CONSIDERATIONS

This child is easily distracted by things around him and may be unable to follow prompts for posing or even sitting still. He may have

difficulty following instructions, even if he understands and isn't trying to be contrary. He will often talk excessively and tends to interrupt others. This sometimes impulsive, overactive child may fidget with his hands while constantly squirming in his seat. He may have difficulty remaining seated when asked to do so. Actions could also involve disregard for equipment. Having a parent or an assistant on alert in the room is a good idea when photographing a child with significant ADD or ADHD.

Sally Harding took advantage of an outdoor location and natural light to photograph Chris, a young man with ADHD.

AGE CONSIDERATION
Younger children can exhibit tantrums and older children may have low frustration tolerance. Although impulsiveness and hyperactivity tend to diminish with age, inattentiveness and related symptoms will remain in adulthood.

THE PHOTO SESSION
Location
If hyperactivity is an issue, a home shoot or outdoor location should be considered.

Greeting/Approach
Start with a verbal greeting. Eye contact is vital. Do not reach out to touch these children unless invited to do so.

Lighting
Natural outdoor lighting without flash or where a flash is not so obvious would be a good choice for this child.

Sounds
Soothing music or "elevator music" that does not draw attention may be calming. Keep in mind that abrupt changes from one song to another could be problematic for this child. Use equipment that will make minimal sounds.

Attention-Getter
Don't use techniques or items that make startling sounds. Employ the novelty of your activity or prop to keep the child's attention—this is an important tactic.

Props

Discuss using various types of props with the parent during the pre-session interview. Hide all other props and "extra" equipment from view. (This is another reason to avoid a studio setting.)

Sitter's Focus

This child may have a limited capacity to follow your instructions to focus in a certain direction.

Special Considerations

It may be difficult to retain this child's attention during the photo session because of distractions from objects in the room. Use short, to-the-point statements. Provide frequent visual and verbal feedback. These children may have difficulty following through on instructions and are easily distracted by extraneous stimuli. They have difficulty waiting and will interrupt inappropriately. Provide frequent breaks and supplement verbal instructions with visual instructions.

You may also wish to segment your time during the sitting. Say, "We will do *this* (photo session) for two minutes." (Use a large timer, giant wall clock, stop watch, or an hour glass with stand.) "Then we will do what *you* want to do." Role play with a prop camera for a while so the child can pretend to take pictures of the photographer, then go back to taking photos of the child.

These children may have difficulty following through on instructions and are easily distracted by extraneous stimuli.

AUTISM

*C*HILDREN WITH AUTISM DO NOT DEVELOP NORMAL language skills or social relationships and can behave in compulsive and ritualistic ways, sometimes failing to develop normal intelligence. This disorder is two to four times more common in boys than in girls. This child generally prefers to be alone and doesn't form close personal relationships, won't cuddle, doesn't like hugging or touching, avoids eye contact, resists change and becomes excessively attached to familiar objects. These children are most often "in their own little world" and have little concern for the wishes of persons outside it.

ROOM PREPARATION

This child may best be served at home or in familiar surroundings. If in the studio, protect valuable equipment and clear an open path, free of cords or other paraphernalia. Use of an assistant is recommended to help with the sitting.

SEATING PREPARATION

Children with autism may not be able to follow direction to sit a certain way or hold still. A rocking chair or swivel secretarial chair provides comfort and may be a good choice for seating. Other possible platforms could include a swing or hammock. Prepare to snap the photo "on the fly"—they like to spin objects as well as themselves.

WHAT TO EXPECT DURING A PHOTO SESSION

This child is likely to have an extremely low attention span and may not be able to follow directions. They will not be able to sit for long. Protect against losing the child's good humor. Tantrums are common. If you "lose" them, the sitting may need to be rescheduled—

This child generally prefers to be alone and doesn't form close personal relationships . . .

and you should consider a different location for the next sitting.

● COGNITIVE OR PHYSICAL CONSIDERATIONS
Electronic hums, mechanical noises, beeps, or unusual, out-of-context sounds could trigger an unwanted response that could become uncontrolled and require the need for rescheduling. Strange mannerisms could be present with unusual speech patterns. Some children can exhibit obsessive-compulsive behavior or hyperactivity. They may exhibit quick and repetitive hand or finger flips. They also tend to rock or pace. Verbal responses are repetitive. Your best response is to repeat back what they have said to confirm communication. Tantrums are common. There could be aggressive behavior with striking out physically. Practice reserving a personal space between this child, you and your equipment.

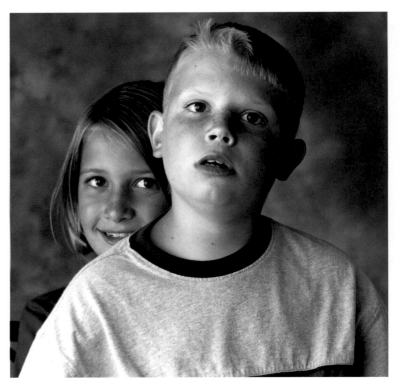

Above and Facing Page—Thomas Balsamo photographed Joseph in his studio, using lighting that allowed for the brother and sister to move and interact.

● THE PHOTO SESSION

Location
Consider a home or outdoor location shoot for this child where natural lighting can be easily applied. This child may be most comfortable in a therapy room that has special equipment with which the child is comfortable.

Greeting/Approach
Do not reach out to touch this child. Do not invade their personal space unless they invite you in. Just greet them by name with a warm welcome.

Lighting
Natural lighting may be best for this child. Bright lights that "pop" or flickering lights could trigger behavior problems.

Sounds
Relaxing music may work well with this child. Take care not to cause any sudden change in sound. Clear the sitting area of strange or unusual sounds such as humming fluorescent lights, rattling air conditioning ducts or squeaking equipment. Such unusual sounds can be disturbing to this child and may cause a need for rescheduling.

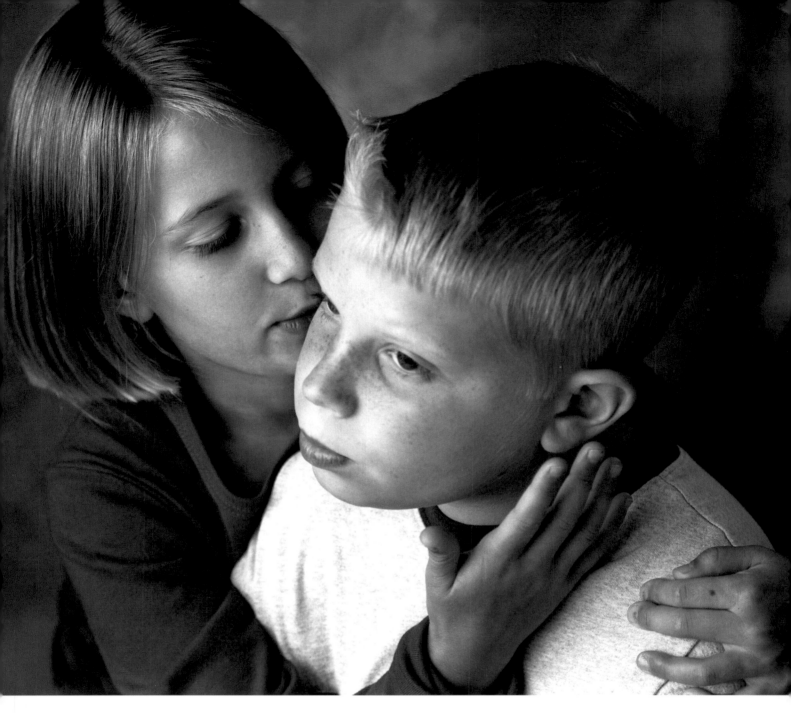

Attention-Getter

Use a gentle approach with "attention-getters" when working with an autistic child. They are attracted to spinning objects. Tops or small handheld wands with metallic streamers can be useful. Direct their attention to a spinning or rocking object and quickly take the picture!

Props

Motor skills for these children are often quite good. They might be able to hold props (for a short period of time). They become attached to certain objects called "comfort objects," which could be a coffee can lid, a stick or another unlikely article. Consult the parent about bringing one or two items along in a bag. A large item may be

easily concealed in a large garbage bag or pillowcase to disguise it prior to the shoot.

Posing

Do not reach out to adjust the pose of a child with autism (providing you are able to get them to sit in one place). Allow them to protect their own zone. If the child is unable to pose, do not use a tripod. This way you can more easily follow the child around the room and adjust the height and angle for the shot.

Sitter's Focus

The child with autism may not respond to a prompt to look in a certain direction. He may persist in looking in another direction when spoken to and have limited ability to smile on demand.

Special Considerations

These children may be fearful, withdrawn and/or noncommunicative. They may also exhibit repetitive or unusual behaviors and may be limited in their abilities to respond to verbal cues. These children do not like change in their daily routine—this includes a photo sitting, especially in a strange studio or outside in an unfamiliar location. These children may have no fear of something dangerous. They may laugh inappropriately, display insensitivity to pain, not enjoy cuddling, engage in sustained unusual or repetitive play, avoid eye contact and prefer to be alone. They may use gestures for communication and have inappropriate attachments to objects.

This tranquil portrait of Emma was created by Eric Benjamin.

BLINDNESS

*T*HE CHILD MAY NOT HAVE TOTAL LOSS OF EYESIGHT TO BE classified as blind. Some blind children can see objects or "dark shadows" in front of them or have extremely limited peripheral vision. Ask the parent or child about the extent of visual ability.

ROOM PREPARATION

Do not leave loose cords or clutter in the path of this child. Explain what is around her in the room. Continue to talk and explain as you prepare. Take cues on how to do this from the parent/escort. It might also be nice to take the child on a tactile (touch) tour of the room and the equipment before beginning.

It might also be nice to take the child on a tactile (touch) tour of the room . . .

SEATING PREPARATION

Do not use a high stool that would be difficult or frightening for the child to access or "perch" on. A chair with arms, a bench or a step might be a good choice for the blind child. If the child has some vision, let them experience the flash before actually beginning.

WHAT TO EXPECT DURING A PHOTO SESSION

This child needs information when in a strange setting. Keep talking and explaining what you are doing and what you would like the child to do.

COGNITIVE OR PHYSICAL CONSIDERATIONS

A diagnosis of multiple disabilities may include blindness and or an inability to control eye movement. The primary diagnoses must be considered in addition to blindness.

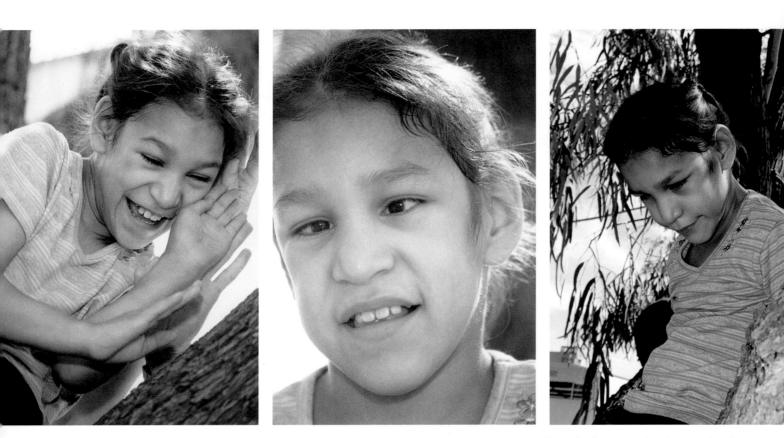

AGE CONSIDERATIONS

The older the child, the more understanding she will be of your directions, and the more able she will be to interpret and respond to your requests.

THE PHOTO SESSION

Location

No special consideration for location necessary.

Greeting/Approach

Start with a verbal greeting. Softly talk to the child before touching them. Tell them what you are going to do before you do it—for example, you can ask, "May I shake your hand?" Extend your hand and take theirs in yours. Or put a hand on their shoulder to let them feel your presence (if blindness is the only disability).

Lighting

Ask if they are sensitive to light. Otherwise, no special lighting consideration is necessary.

Sounds

Background music or sounds are not recommended. The child will be concentrating on what you say, and may be able to focus better

Elisa also has some developmental problems. She needed a few helping hands to keep her from flying out of the tree, because she is continually on the move. She also loves to grab you for a hug and will hold on very tight.

without distractions. If music is used, keep it melodic and low-key with familiar songs that encourage participation (remembering to keep the music age-appropriate).

Attention-Getter

You can use tactile prompts to allow the child to be involved in the process. For example, let them touch a toy rattle before you shake it. If the child is older, allow them to touch the camera before the picture is taken. If some sight is present, ask the child "Can you see this?" Knowing your limits with this child will be useful. Objects that make sounds work well with children who have low or no vision.

Props

Use props that will be comfortable to hold. Ask the parent to bring a few of the child's favorite objects.

Posing

Cues for head positioning need to be clearly defined by saying, "Turn your head just a little to the right." If the child does not understand "left" and "right," ask the parent to get the child into position.

Sitter's Focus

If some vision is present, try a small light or a shiny object if you want to guide focus to a specific direction.

Special Considerations

This child may need specific vocal cues for positioning, such as, "I am on your left about five feet in front of you," or "Face toward the camera; it's about three feet in front of you." You may need to guide them with a touch on the elbow.

Chapter 8

BRAIN ABNORMALITIES

S OME CHILDREN MAY BE BORN WITH ONE OF MANY TYPES OF brain disorders. The child shown here has Aicardi syndrome, a rare genetic disorder with fewer than 300–500 cases worldwide. This particular syndrome affects only females and is

Ashtyn's parents were delighted with the results of this photograph because she is blind and has her eyes closed most of the time. This photo, captured by Laura Popiel, represents the way the parents know and love their daughter.

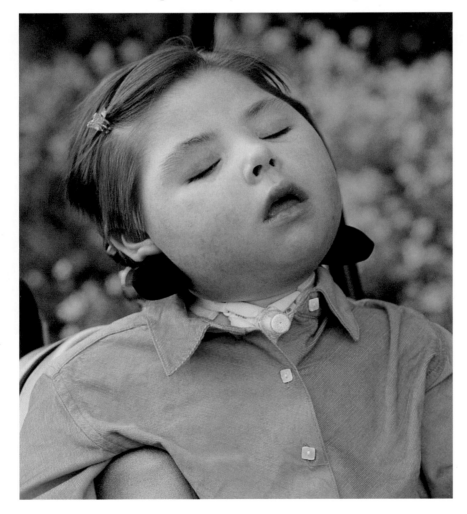

characterized by the absence of the part of the brain that allows the right side to communicate with the left, infantile spasms, mental retardation and lesions of the retina of the eye.

ROOM PREPARATION
Children with severe brain conditions are usually in a wheelchair. Clear a safe pathway, free from cables, cords and other paraphernalia.

SEATING PREPARATION
Discuss with the parents the best way to transfer the child from a wheelchair to another type of seating arrangement.

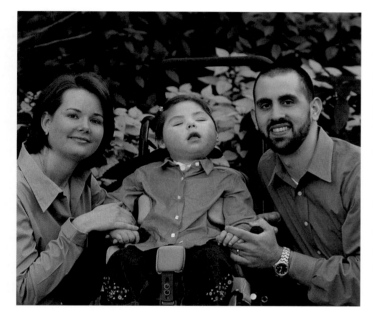

A natural-light setup is flattering for this family grouping. Photo by Laura Popiel.

WHAT TO EXPECT DURING A PHOTO SESSION
A child who is severely affected by a brain disorder will most likely show very little or no response to directives. Nevertheless, they often have people to whom they warm up very well. Don't expect eye contact or even eyes that are open for very long.

COGNITIVE OR PHYSICAL CONSIDERATIONS
There are both cognitive and physical considerations for children with brain conditions. A child with limited brain function may not warm up to strangers very well.

AGE CONSIDERATION
A significant number of infants with brain abnormalities may not show any sign of defect until around the age of three months when they begin to have spasms or other signs of abnormality.

THE PHOTO SESSION
Location
An outdoor setting provides a splendid, idyllic locale for a child whose condition precludes very little movement or response.

Greeting/Approach
Use a friendly greeting as though you would be expecting a response, then move on.

Lighting
Natural lighting is best for this type of condition.

Sounds

Unusual sounds or music may be distracting, especially to a child who is blind.

Attention-Getter

Ask the parents to help with this. You may not be able to attract this child's attention on your own.

Props

Consult with the parents regarding appropriate props.

Posing

In most cases, the child will need to be positioned manually by the parent or caregiver.

Sitter's Focus

The child with this or another similar condition will most likely not be able to focus in a certain direction.

Special Considerations

Go with the flow. Allow the parent or siblings or animals to interact while you snap the pictures.

Allowing the parents and siblings to interact while you snap the picture can yield heartwarming pictures like this.

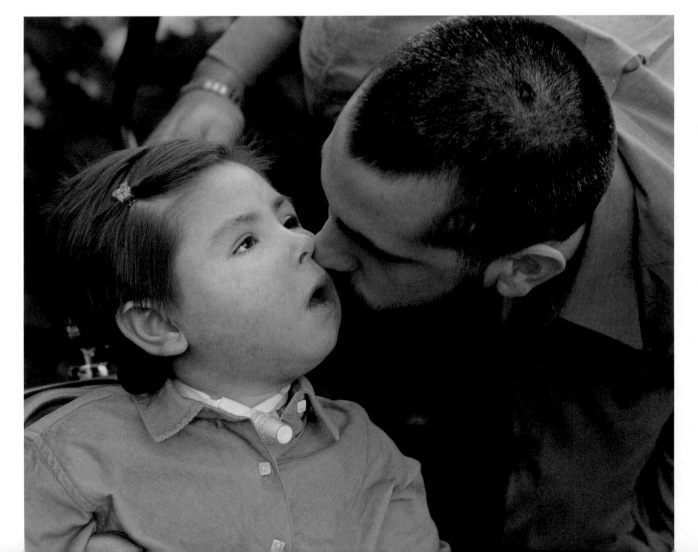

CEREBRAL PALSY (CP)

C HILDREN WITH CEREBRAL PALSY CAN BE SEVERELY disabled or only mildly affected by the disorder, evidenced by barely noticeable awkwardness to severe spasticity that contorts the arms and legs and confines the child to a

Katie, like many other children, loves to dress up for photos, fashion shows and Halloween. Glamour Shots captured this lovely image of Katie wrapped in glistening gossamer. This is a rare image where Katie provides eye contact for the photographer.

wheelchair. This condition is characterized by poor muscle control, spasticity, paralysis and other neurological deficiencies resulting from a brain abnormality that occurs during pregnancy, during birth, or even after birth.

ROOM PREPARATION

Allow plenty of room for a wheelchair and the occasional spastic movement of arms into the space around the chair. Remove cords, and cover or pad sharp edges on lighting or reflection equipment.

SEATING PREPARATION

Some parents or children prefer not to have assistive technology, like wheelchairs and breathing tubes, show in the photo. The parent must have control over assistive technology. Prepare to use a drape or ask about transferring the child to a beanbag or other seating for support. Children with CP may not transfer to alternate seating.

WHAT TO EXPECT DURING A PHOTO SESSION

Many children with CP do not respond to prompts. Ask the parent to help. A camera or strange setting may intimidate the child and cause increased spasticity. In all forms of cerebral palsy, the child's speech may be difficult to understand, because he or she has difficulty controlling the muscles involved in speech.

COGNITIVE OR PHYSICAL CONSIDERATIONS

Strong emotion makes the physical issues worse; sleep makes them disappear. Many of these children (less than half) have excellent intelligence and thought processes but are unable to express themselves because of physical constraints. A large percentage of children with cerebral palsy have other disabilities and below normal intelligence, while still others have severe mental retardation. Some use a spelling board or recorded message pad or may have their own personal method of communication. Find out what their special language is and use it!

AGE CONSIDERATIONS

None.

THE PHOTO SESSION

Location

These children may be more comfortable at home or outdoors in a pleasant setting. Camera equipment and lighting may be disconcerting for this child.

Facing Page—Lliam has cerebral palsy with mild autism. He has some ability to follow a photographer's directions, but responds better to his mother's prompts. Photograph by Sally Harding.

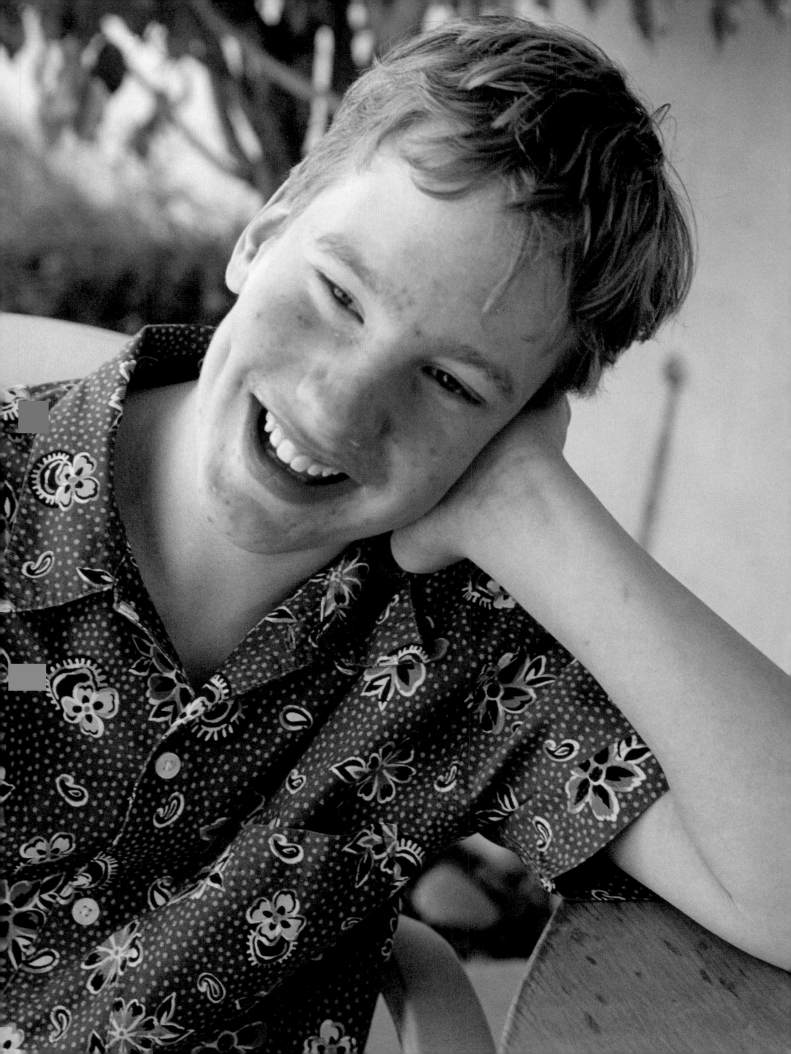

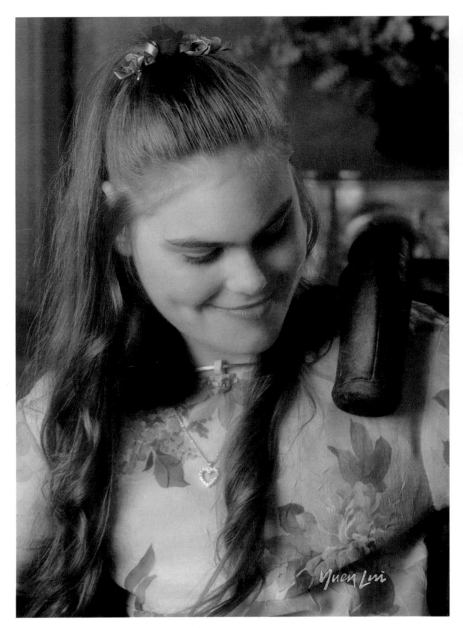

Left—Katie is extremely photogenic but not often in a good position for capturing a photo to show her beautiful smile. Photographer Tony Wang, of Yuen Lui Studio, says that the two vital keys for photographing children with special needs are patience and the ability to move quickly, capturing the perfect moment when it happens.

Above—Katie "models" for Sally Harding in a photography workshop presented by the Picture ME Foundation.

Greeting/Approach
Use a friendly approach and do not expect a reply, but try waiting a moment for a delayed response.

Lighting
Natural lighting would be a good first choice. A child with cerebral palsy could become extremely withdrawn with increased uncontrollable movement in artificial settings that include a lot of photo equipment and lights.

Sounds
Most parents of children with cerebral palsy report that their child really likes music. Avoid loud or sudden sounds, however. Music may

also be calming. Recordings of outdoor sounds such as birds, streams or the ocean might be a good choice, too. Be sure the music does not interfere with verbal communication. Children with good receptive skills will often respond well to chit-chat.

Attention-Getter
In the case of an anxious, severely impaired child, you may not want to attract attention or create an obvious presence near the child. Try using a baffle to conceal both you and your camera. This apparatus could be affixed to camera lens or the legs of your tripod. Other children enjoy the attention and unique surroundings. Check on this during the pre-session interview. See page 108 for some baffle ideas.

Props

Children with cerebral palsy may not be able to hold small objects.

Many of these children have special objects such as a musical keyboard or laptop computer with which they like to interact. Ask about their preferences prior to the session and invite the parent to bring along one or two favorite items. Children with cerebral palsy may not be able to hold small objects. Large objects may rest on their wheelchair (such as a musical keyboard). Some children may want to read a book that can rest on the tray attached to their wheelchair.

Posing
The child may have limited ability to move or pose. Head movement may increase or be induced by emotions such as joy or fear or just plain excitement. Expressions of joy may be exhibited by jerking the head back and opening the mouth very wide.

Sitter's Focus
Children may not be able to respond to a request to smile. They may, however, respond with a happy reaction to something that strikes them as funny or hits an emotional button.

Special Considerations
Keep a box of facial tissues nearby for mouth bubbles and drooling. Some children will shriek out with utterances of glee or emotional response. React to them as though it were a giggle or laugh from any other child. Enjoy the moment with them.

Chapter 10

COGNITIVE DISABILITIES

*T*HIS IS A VERY BROAD CATEGORY THAT RELATES TO AN individual's ability to think and process information. Low cognitive function can be a part of Down syndrome, cerebral palsy or a brain condition and combined with other limitations such as blindness or loss of hearing.

● ROOM PREPARATION
The child with cognitive issues may span the range from mildly to severely involved. Discover the extent of the involvement during the pre-session interview and prepare the room accordingly.

● SEATING PREPARATION
Discuss the child's abilities and preferences during the pre-session interview.

● WHAT TO EXPECT DURING A PHOTO SESSION
Expect to have fun in the challenges of finding ways to get a child to smile and laugh. If the child seems anxious, take some time to help them get comfortable in the environment.

● COGNITIVE OR PHYSICAL CONSIDERATIONS
More involved children may not be able to follow verbal directions. Others may have difficulty with your demonstrations as well. With extreme cognitive disability, do not anticipate much movement. Smiles may be out of the question.

● AGE CONSIDERATION
No special considerations.

Location

At home with loved ones may be the best location for a beautiful candid shot. Severe cognitive disability could create problems in a studio setting because many of these children have difficulty adjusting to unfamiliar settings and individuals. Consult with the parent or caregiver for the most appropriate sitting venue. After reviewing the extent of the child's disability, determine the best location for photography. A beanbag chair may be a useful seating arrangement for this child.

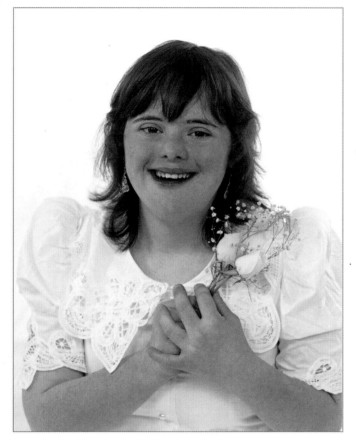

Katy, who has Down syndrome, was photographed by Dina Ivory.

Greeting/Approach

Use a normal greeting.

Lighting

No special consideration.

Sounds

No special consideration.

Attention-Getter

Consult with the parent to learn which items will attract or hold this child's attention. Try a baffle (see page 108) or select other age-appropriate items.

Props

Have the parent supply the prop or ask about another type of prop that would be appropriate.

Posing

Take into consideration the child's ability to follow verbal directions and demonstrations or to be passively positioned. Resort to a "free play" type of shoot, if needed.

Sitter's Focus

Learn what the child likes in order to invent "games" that will hold his attention and elicit a response.

Special Considerations

This child may have difficulty with her attention span or exhibit timidity. Get to know the child by spending some unstructured play time with her prior to the official photo session.

Chapter 11

CONNECTIVE TISSUE DISORDERS

AYLOR, THE LITTLE GUY THAT STARTED THE AWARENESS FOR improved portrait studio services for professional photographers, has a connective tissue disorder that doesn't have a name and the cause is unknown. Other connective tissue or bone disorders may be hereditary.

Arthritis is also classified as a connective tissue disorder. Arthritic children are mainly affected by rheumatoid arthritis, an autoimmune disease in which joints, usually involving the hands and feet, are symmetrically inflamed, resulting in swelling and pain. Severely involved children require special care and attention.

ROOM PREPARATION
Prepare for easy access. Remove clutter, invasive equipment and loose cords.

SEATING PREPARATION
Some (especially younger) children may require back support due to restrictions in their movement or spinal weakness. Have firm pillows handy, a stiffly stuffed toy to lean against, a basket to sit in or a bean-bag chair for reclining. Ask the parent's preference. Siblings also make great "living" supports.

WHAT TO EXPECT DURING A PHOTO SESSION
Expect a normal sitting, but with some additional physical considerations to provide for the child's comfort and safety.

COGNITIVE OR PHYSICAL CONSIDERATIONS
Generally, there is no cognitive involvement; nevertheless, it can occur in some children. Physical limitations are generally overcome

Expect a normal sitting,

but with some additional

physical considerations . . .

with a physical support or other positioning strategies. Arthritis can be an extremely disabling physical condition. Inflamed joints are usually stiff, especially in the morning and after prolonged inactivity. Schedule the appointment for the child's best time of day.

AGE CONSIDERATIONS

Many children with connective tissue disorders may look younger than their age. Treat them according to their actual age. Their mental ability can be "right on" or even exceed other children of the same age.

Taylor, who has a connective tissue disorder that doesn't have a name, was photographed sitting on the ledge of a natural backdrop created by a large rock.

THE PHOTO SESSION

Location

No special consideration for location.

Greeting/Approach

Use your favorite greeting. Light touch with a handshake is okay.

Lighting

No special lighting consideration is necessary.

Sounds

No special sound consideration is necessary.

Attention-Getter

No special consideration is necessary.

Props

Use props that will be comfortable to hold. Very young children may require some propping up, because many are small and underdeveloped for their age.

Posing

Posing should be arranged to minimize distortions in fingers, arms or legs. Some children may not be able to physically position themselves in a way you suggest, because their arms or legs do not have much flexibility. Other children may be overly flexible, causing a child under two years of age to require support when sitting. Always ask if

they can accomplish a certain move, rather than directing them and then expecting an immediate response.

Sitter's Focus
No special considerations necessary.

Special Considerations
Although these children may be of normal intelligence, their movement may be limited in certain ways.

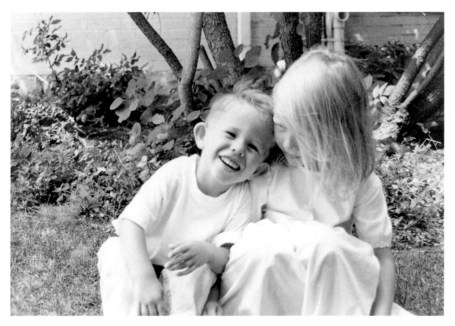

Siblings make wonderful "props" and photo companions for children with disabilities. Photograph by Nancy Van Matre.

DEAFNESS OR HEARING IMPAIRMENTS

W HEN CHILDREN ARE DEAF OR HEARING IMPAIRED, problems may sometimes be corrected with a hearing aid. These children will be more confident if you follow some simple rules for working with those who have hearing problems. A disability such as Down syndrome may include hearing loss as an inherent component. If the child uses sign language, talk through an interpreter. Learn a few key words in sign language just to show you care and are trying to communicate (see pages 110–11 for suggestions).

Learn a few key words

in sign language

just to show you care

and are trying to communicate.

ROOM PREPARATION
Use a well-lit room so the child can easily see your face and lips.

SEATING PREPARATION
No special seating is necessary unless another disability is present.

WHAT TO EXPECT DURING A PHOTO SESSION
If the child has no assistive device, he may have a tendency to speak louder than expected. He may also be difficult to understand.

COGNITIVE OR PHYSICAL CONSIDERATIONS
Always face the child when you speak to him so he can see your face and lips. Do not speak with something in your mouth, such as a pen or pencil, or speak from behind the camera. If necessary, use hand gestures or a written message.

AGE CONSIDERATIONS
Younger children may be less able to understand your directions than older ones.

THE PHOTO SESSION

Location
No special consideration for location.

Greeting/Approach
Greet the child normally. Extend your hand or place it on his shoulder or back with a warm greeting.

Lighting
Begin in a well-lighted room and try to stay in the light so the child can see your face and lips.

Sounds
No special sound accommodations are necessary.

Nicholas (on the right) was photographed with Benjamin by Laura Popiel outdoors under natural light.

Attention-Getter
Something bright and glittery is a good choice for attracting the attention of a younger child.

Props
No special consideration for props.

Posing
Determine ahead of time the communication you will use in providing the child with prompts to have him turn and face in the direction you choose.

Sitter's Focus
No special consideration for child's focus necessary.

Special Considerations
To communicate, use an interpreter (if available). If not, you may choose visual cues for posing, such as a written sign or hand signal. If the child reads lips, make sure to stay within the line of his vision when speaking. Do not cover your mouth or put anything in your mouth when speaking.

DEVELOPMENTAL DISABILITIES

*D*EVELOPMENTAL DISABILITY COVERS A WIDE RANGE OF disorders and conditions and may have cognitive, sensory and physical implications. This category may include children diagnosed with Down syndrome or cerebral palsy, among others. The child shown here has multiple disabilities.

ROOM PREPARATION
Many children are in wheelchairs; others are fully ambulatory. Discuss the degree of disability with the parent or care provider during the pre-session interview.

SEATING PREPARATION
If the child is most comfortable in a wheelchair, attempt to move him to a solid area of the carpet and aim the camera down to avoid capturing clutter in the background. If the child is ambulatory, use a comfortable seating arrangement. Work quickly, as this child may have a limited ability to sit still in one place.

Work quickly, as this child may have a limited ability to sit still in one place.

WHAT TO EXPECT DURING A PHOTO SESSION
There is a wide range of ability, so get specifics from the parent.

COGNITIVE OR PHYSICAL CONSIDERATIONS
This category is too broad to list all the considerations that may apply to the developmentally disabled child. This makes it especially important to get specifics from the parent.

AGE CONSIDERATION
The child with this condition is slow to develop and may never fully reach the potential of other children their age.

Location

No special consideration for location other than accessibility issues.

Greeting/Approach

Use your favorite friendly approach. Do not touch the child unless invited to do so.

Lighting

No special lighting considerations. Ask about seizures with respect to lighting.

Sounds

Upbeat or relaxing music may provide a nice background sound for this child (if not distracting). Avoid sudden changes in type of sound or loud noise.

Attention-Getter

If possible, have the parent or attendant provide prompts that will evoke a pleasant response.

Props

Try bright props such as puppets.

Posing

The child may have only a limited ability to follow cues. He may be very gregarious but have difficulty sitting in one place for long.

Sitter's Focus

The child may not be responsive to a prompt for a smile. Try to capture a natural moment of pleasure or enjoyment.

Special Considerations

Always consult the parent or caregiver about other disabilities that may be present in a child that whose condition is described using the general term "developmentally disabled."

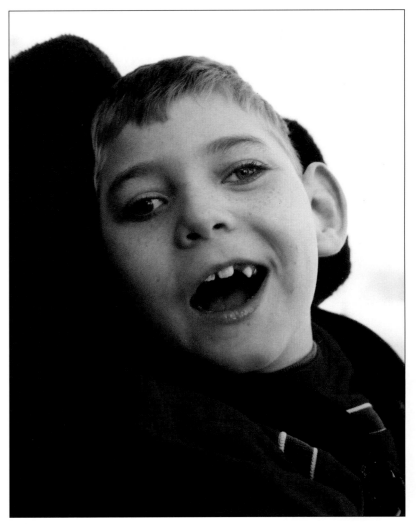

Alec's abilities are equated to that of a young infant. Sally Harding captured this portrait of him while he was safely secured in his wheelchair.

DOWN SYNDROME

ENERALLY, THESE CHILDREN ARE VERY LOVABLE AND extremely social. Their unique facial features include pronounced eyes, round face and short, stocky stature. Most have an enlarged tongue and many have respiratory and/or heart condition. Many children with Down syndrome can also be hard of hearing, requiring a hearing device or increased volume when communicating. It is important to build a bond and develop a rapport with this child. "Personalize" the relationship through recognition of their "beautiful smile" or their "lovely blond hair that looks like a rock star's." However, begin by providing space for this child.

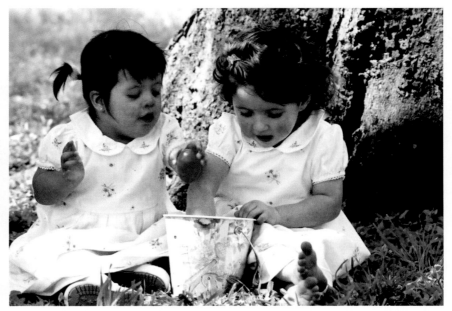

Katelyn and Alyssa are twins, but only Katelyn has Down syndrome. Laura Popiel used the soft light in the shade of a tree to create two natural-looking portraits of the two sweet girls in their summer dresses.

ROOM PREPARATION

Try placing some posters above and behind you (and the camera) on the wall. This encourages sitting straight and looking up (there is a tendency for poor posture). These children do not generally like waiting; so have the room prepared and ready to go. Have a box of soft facial tissues nearby to wipe the child's mouth or runny nose (these children often have colds, due to their susceptibility to infection).

SEATING PREPARATION

Stool, chair, beanbag chair, steps, floor, therapy ball, lawn—all should be okay for the child with Down syndrome.

WHAT TO EXPECT DURING A PHOTO SESSION

Consult with parent about the child's capacity to sit still. These children can become frustrated easily. Alerts to a child's end of endurance are when he or she becomes fidgety or emits heavy sighs. Frustration may also be indicated if the child starts to suck his fingers, rock or moan. Provide breaks. Take a short walk or have brief diversional play. Stay in charge; these children need to feel secure. Be aware of muscle tone issues; children with low muscle tone around the face may not be able to smile well. After getting to know this child, hugs (with permission) are often reinforcing and much appreciated.

COGNITIVE OR PHYSICAL CONSIDERATIONS

Some mental retardation may be present. Developmental disability varies from child to child. Speak clearly. The child may demonstrate poor motor skills but could work well with a large prop such as a therapy ball.

THE PHOTO SESSION

Location

A location allowing movement for this child is a good choice. Studio settings are also fine, because some kids enjoy traditional poses.

Greeting/Approach

You can use a traditional greeting style. Handshakes are also appropriate and are generally well received. Establish a relationship early on. Try offering a small, brightly colored object such as a pencil with a toy-shaped eraser. For example, Tiffany (shown to the right) was shy and reticent until the photographer offered her a bright pencil with clown eraser. After getting to know the Down syndrome child, try a friendly "high five" (but always ask first). Compliment them; be charming.

Top and Bottom—For Tiffany, a playful look (top) worked much better than a studious one (bottom)! Tiffany was my very first model as I began the research for this book. Not knowing what to expect, I was as apprehensive as she was! The "ice breaker" was the gift of a colorful pencil and eraser. Music helped move everything along.

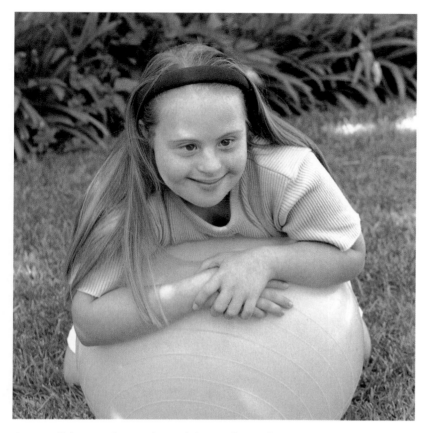

Sitting still for very long in front of the camera was not an option. But when, like a beautiful butterfly, Tiffany alighted on something, the photographer was there to capture it.

Lighting

Studio lighting is okay, but be sure to ask about the child's sensitivity to light.

Sounds

Many children with Down syndrome like music—sometimes with specific preferences such as Elvis, "oldies" or country. Something appropriate for dance movements would also be worth trying. Play a complete song without changing it unless the child doesn't want to hear it. Some children can become upset if they are enjoying a song and it is suddenly turned off.

Attention-Getter

Use age-appropriate items. Bright colors may work well. An "authority figure" representing a policeman or fireman can also make a good impression. For older children, popular movie stars, well-known athletes or noted singers are generally effective visuals.

Props

Live animals generally work well for children with Down syndrome. If a live critter is not an option, try substituting with an high-quality, age-appropriate stuffed animal. It's nice to offer a choice between two items when presenting a prop. Eye contact from the photographer to the child is important. These children also tend to enjoy bright colors. *Note:* Take care not to pass stuffed animals from child to child; these children are often susceptible to infection. Keep a box of soft facial tissues nearby to assist with colds or possible drooling (caused by an enlarged tongue) or for the often present runny nose.

Posing

Posing may or may not be a challenge with this child. Plan on "catching" a special moment in dance or play. Be aware of low and possibly "floppy" muscle tone.

Sitter's Focus

This depends on the individual child. Some Down syndrome children tend to cross their eyes if looking directly into the lens or when asked

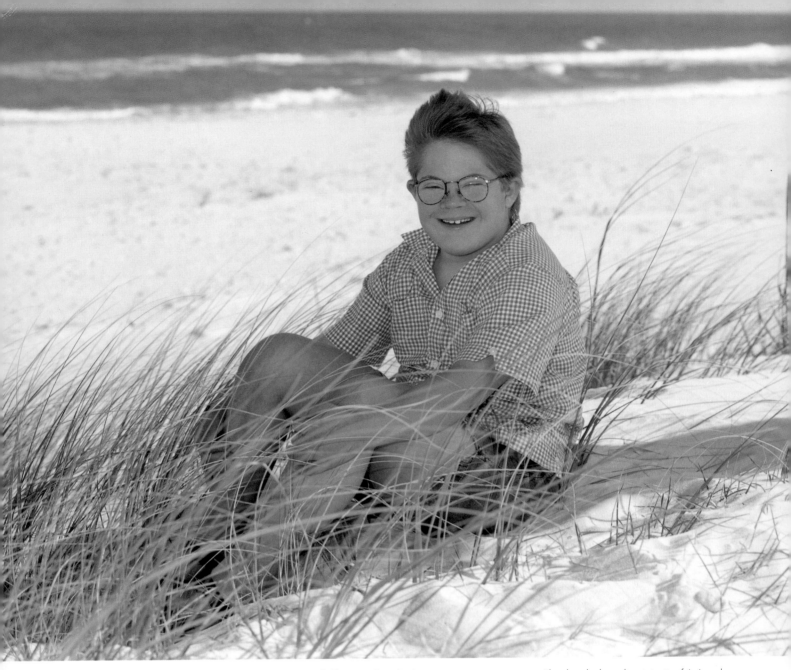

to focus on a specific object. Carefully study their eye movement prior to posing or using film. Talk about actions before you request them. Click the shutter when the child is relaxed.

This lovely beach portrait of L. J., a boy with Down syndrome, was created by Dina Ivory.

Special Considerations
Be consistent in your directives and have solid follow-through; don't change your mind after making a suggestion. These children generally photograph well when accompanied by friends, siblings, familiar objects or pets. Encourage the child to look at you and make eye contact for direction and reassurance.

EHLERS-DANLOS SYNDROME

EHLERS-DANLOS SYNDROME IS A RARE HEREDITARY connective tissue disorder that can result in unusually flexible joints, very elastic skin and fragile tissues. This flexibility tends to decrease over time and with therapy. Variations of the disease can include significant scaring from wounds that are slow to heal. Some children have a tendency to bleed easily.

Sam's mother was concerned about his inability to sit unassisted while being photographed, due to lack of muscular control caused by Ehlers-Danlos syndrome. The problem was solved by placing him in a basket with a brightly colored blanket. Photograph by Teresa Nagy.

ROOM PREPARATION

Clear the room of sharp or protruding objects that could inflict accidental injury.

SEATING PREPARATION

Any type of seating is appropriate, with an eye toward safety to prevent falling and injury.

WHAT TO EXPECT DURING A PHOTO SESSION

These are generally charming children with special physical considerations, and perhaps limitations.

COGNITIVE OR PHYSICAL CONSIDERATIONS

Expect this child to have normal intelligence, unless you are told otherwise. This child may be fragile in some ways, so guard against accidental injury. Some kids develop an abnormal curvature of the spine.

AGE CONSIDERATION

The younger the child, the more acute his condition may be.

THE PHOTO SESSION

Location

Even though outdoor venues are always good, activity in the "wild" should be carefully planned and controlled due to this child's possible fragile physical condition. If a fall and wound should occur, the

child could experience difficulty with healing and tendency for scarring from injuries. They respond well to prompts in a studio setting.

Greeting/Approach
Your favorite style of greeting will be appropriate.

Lighting
No concerns about lighting.

Sounds
No special consideration for sound.

As this portrait of Joshua by Teresa Nagy shows, children with special needs enjoy showing off their special skills as much as any other children!

Attention-Getter
Use age-appropriate items.

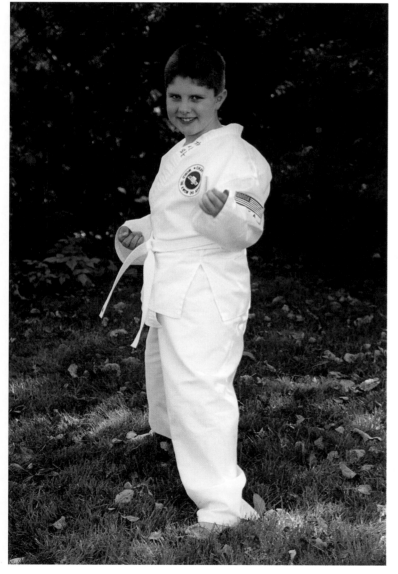

Props
Any age-appropriate prop is acceptable.

Posing
Natural poses work well with this child. Special props for seating may be needed, especially for children under two years old. In the photograph on page 75, the photographer used a basket to support a child who was unable to sit unassisted. Catch them doing what they enjoy.

Sitter's Focus
No special consideration necessary.

Special Considerations
Once again, protect this child from injury.

EPILEPSY (SEIZURES)

E PILEPSY IS A DISORDER THAT IS CHARACTERIZED BY THE tendency to have recurring seizures. Children with various other primary diagnoses may also have a tendency to experience seizures. Epileptic seizures may be triggered by stimuli such as repetitive sounds, flashing lights, video games or even touching certain parts of the child's body. Children who have a tendency toward epilepsy can appear to act just as any other child. Modern drugs are used by many children to keep most episodes under control. Triggers are stress, anxiety and fatigue—in addition to those mentioned above.

Children with tendency toward epilepsy can appear to act as any other child.

Room Preparation
Make certain that there are no unusual sounds or flickering lights (including strobe and fluorescent lights).

Seating Preparation
Avoid high stools from which a child could fall during a seizure (even mild seizures can cause disorientation).

What to Expect During a Photo Session
During the interview with the parent or care provider, ask about the proper procedure and triggers to avoid. Incidence of seizures in children with neurological diagnoses (i.e., cerebral palsy or traumatic brain injury) is high.

Cognitive or Physical Considerations
How can you tell if a child is having a seizure? Some warning signs are: the arm or foot may begin to shake and jerk and the child may stagger, move the arms and legs in a strange manner, utter meaning-

Natural light is an excellent choice for children with epilepsy or who suffer seizures related to other primary diagnoses. Scout put her head on a toy chest just long enough for Sally Harding to snap a photo. The light from a window cast warm light on the girl's happy face.

less sounds, fail to understand what you are telling them and may also resist help. With mild seizures, confusion may last for several seconds, followed by full recovery. More extreme seizures can involve convulsion, loss of consciousness, severe muscle spasms and jerking throughout the body, intense turning of the head to one side, clenching of teeth and loss of bladder control. Following the seizure, the child may have a headache, be temporally confused and feel tired. Should a seizure occur during the photo session, the person accompanying the child will most likely know what to do. Recent professional advice does not suggest protecting the tongue; sometimes this can do more harm than good through biting and tooth loss. The most important first aid is to protect the child from a fall, loosen the clothing around the neck and place a cushion under the head. If the child is unconscious, roll him onto one side to ease breathing. Do not leave a child alone until they are completely awake and can move about normally. If seizures are a consideration with your model, discuss this possibility thoroughly with the parent or care provider. If you are unsure of what to do, consider calling for emergency care.

AGE CONSIDERATIONS

The larger and heavier the child, the more difficult he will be to handle while he is having a seizure.

THE PHOTO SESSION

Location

An inside or outside location would be appropriate. Carefully consider the lighting when selecting a location (see below).

Greeting/Approach

Greet the child as you normally would.

Lighting

Natural lighting on an overcast day may be your best choice for a child with a high tendency to experience seizures. If on location, watch for flickering sun/shadows under a tree or when the sun dodges in and out behind the clouds, another possible trigger for a seizure. Learn in advance if this is an issue.

Sally Harding turned the world upside down in this portrait of Scout enjoying a silly moment!

Sounds

Avoid repetitive or irritating sounds.

Attention-Getter

No special considerations needed for attention-getters, unless other disabilities are present.

Props

No special considerations needed for props.

Posing

If light is an issue, avoid having the child look in the direction of a strong light while you are posing the picture.

Sitter's Focus

If light is an issue, avoid having the child look into an area that may have flickering lights or light and shadow area.

Special Considerations

Thoroughly discuss the potential for seizure with the parent or care provider. Avoid repetitive or irritating sounds and flashing lights.

FACIAL ANOMALIES

The forgiving effects

of black & white photography

make it a good choice . . .

CLEFT LIP (ONCE CALLED "HARE LIP") IS A DEFECT OF THE skull and face. It is characterized by an incomplete joining of the upper lip, usually just below the nose. Not usually visible—but often accompanying cleft lip—is cleft palate, an abnormal passageway through the roof of the mouth into the airway of the nose. This facial abnormality affects fewer than one in every 1000 births.

The infant shown here was born with several defects, including cleft lip. The artfully exquisite lighting effects created by the photographer present only an image of a beautiful baby girl for the parents who want to have a treasured portrait to show family and friends.

ROOM PREPARATION
No special consideration necessary, unless other conditions are present.

SEATING PREPARATION
No special considerations.

WHAT TO EXPECT DURING A PHOTO SESSION
No special considerations.

COGNITIVE OR PHYSICAL CONSIDERATIONS
The forgiving effects of black & white photography make it a good choice for photographing children with deformities. Carefully plan the lighting and posing from different angles to achieve the most flattering effect.

AGE CONSIDERATIONS

A newborn infant is more likely to exhibit this abnormality than an older child, because corrective surgery may not yet have been performed.

THE PHOTO SESSION

Location
No special consideration unless other conditions are present.

Greeting/Approach
No special consideration.

Lighting
Lighting will be your friend. Take care to use lighting to its fullest advantage—and keep in mind that it's the *shadows* that will be your most helpful asset in this situation. Even if you have not had much call for black & white photography, present it to the parent as a viable option.

Sounds
No special consideration.

Attention-Getter
No special consideration.

Props
No special consideration.

Posing
This is your second most important consideration, after lighting. If you are working outside or where lighting cannot easily be controlled, positioning will be your top consideration.

Sitter's Focus
The child's focus and facial direction is also a high priority to consider when photographing a child with facial abnormalities. Remember, natural lighting and poses are your friend with this child.

Special Considerations
None.

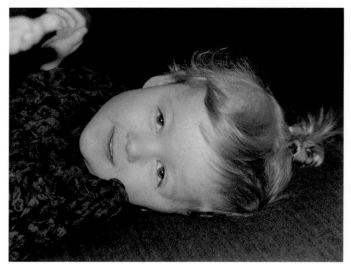

Top—Many complications had to be addressed to capture this image of Leah, who has cleft lip and other facial abnormalities. Photograph by Donna Leicht.

Bottom—Here is Leah at age three. She has undergone many corrective surgeries and is still a challenge to photograph because of other physical and cognitive conditions. Donna Leicht captured Leah enjoying a still moment on the sofa.

HYDROCEPHALUS

REVIOUSLY REFERRED TO AS "WATER ON THE BRAIN," hydrocephalus occurs when spaces in the brain become enlarged with fluid and pressure rises. Hydrocephalus is the most common reason that a newborn may have an abnormally large head. Some children can endure this condition very well and have normal intelligence, while others may have extremely low intelligence. Physical impairment, including the inability to walk, may also occur through brain damage from pressure and lack of development.

ROOM PREPARATION
Some children with hydrocephalus may have to be "followed" with the camera or closely supervised. Prepare accordingly. Consult with the parent.

SEATING PREPARATION
Avoid high stools from which a child could fall. Some children may have a tendency to lose their balance. Ask the parent about the preferred mode for seating.

WHAT TO EXPECT DURING A PHOTO SESSION
Because of the varying degrees of ability among these children, check with the parents as to what to expect and what degree of cooperation and understanding may be expected from their child.

COGNITIVE OR PHYSICAL CONSIDERATIONS
This disorder can present the need for consideration of a wide range of cognitive and physical function. Discuss the extent of the child's abilities with the parent.

Some children with hydrocephalus may have to be "followed" with the camera or closely supervised.

This disorder is usually brought under control at a very young age. Either it stops by itself or is corrected by a shunt. A shunt is a tube that is inserted surgically that allows fluid to drain from the ventricles to the abdominal cavity where the body can absorb it. They can sometimes be seen protruding from the skin at the back of the head or neck. Make adjustments accordingly.

THE PHOTO SESSION

Location
Consult with the parent about the most ideal location for the photo session.

Greeting/Approach
Normal cheerful greeting.

Lighting
No special considerations.

Sounds
Soothing music is good.

Attention-Getter
Ask the parent for suggestions. Baffles may work well here (see page 108).

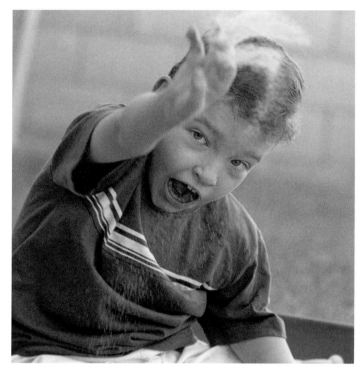

Sally Harding captured this action shot of Nathan playing in the sandbox.

Props
Consult with the parent as to what the child will be able to manage with his hands or in his lap.

Posing
Avoid positions that draw attention to a prominent shunt if concealing this is an issue for the child or family.

Sitter's Focus
Obtaining eye contact with the lens may be difficult in some cases. Check with the parent regarding child's ability to hold a focus and provide eye contact.

Special Considerations
Check with parents about shunts, the child's ability to follow directions and keeping equipment out of harm's way.

ILLNESS—SERIOUS, LIFE-THREATENING OR CHRONIC

S ADLY, CHILDREN CAN SUFFER FROM ALL TYPES OF SERIOUS or life-threatening illnesses. Many of them can be hospitalized for weeks at a time and even participate in schooling on-site. Photos and therapeutic scrapbooking help them (as well as their family) develop coping mechanisms for their disease. Photos provide cherished memories for families and friends.

One photographer shared that she was once called urgently to a hospice where a heartbroken mother requested a photograph of her seriously ill infant who had passed away only moments before. Photos were made of the child, cradled for the last time in the mother's arms.

A child may be undergoing treatment, extremely exhausted, depressed or just feeling downright icky.

ROOM PREPARATION
When shooting at a hospital or rehab center, it's hard to avoid the assorted equipment and paraphernalia that is intrinsic to this child's everyday existence. Aim the lens toward the bed or a solid wall.

SEATING PREPARATION
Ask for suggestions from the child or parent. Pediatric hospitals have playrooms, therapy rooms and other areas suitable for creating a pleasant photograph.

WHAT TO EXPECT DURING A PHOTO SESSION
A child may be undergoing treatment, extremely exhausted, depressed or just feeling downright icky. Be patient. Take rests. Ask the parent if rescheduling might be in order if the child appears to be tiring or is already exhausted when you arrive to take pictures.

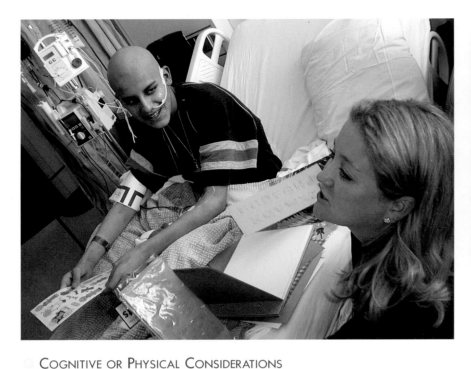

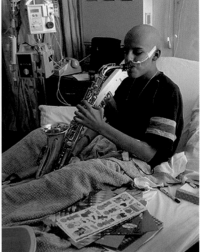

Abram, a cancer patient, was photographed in his hospital room using natural light and fill flash.

○ COGNITIVE OR PHYSICAL CONSIDERATIONS

Even though the shoot is scheduled, a child may be feeling poorly or have little endurance on the day of the sitting. Be considerate.

○ AGE CONSIDERATION

None.

○ THE PHOTO SESSION

Location

Often, a seriously ill child will need to be photographed in a hospital setting. As a variation, try to relocate to a location outside the hospital room (yet still within the institution's confines). Most hospitals have a "serenity garden" or quiet place where patients and family members can go to meditate. Pediatric hospitals may also have a school where the child spends time during the day. Most have playrooms for younger children and some even have a teen room for older kids. Even though they are in the hospital, these alternate settings may provide diverse backdrops for photographs that can be placed in the child's scrapbook or in a family's memory book. If the child is self-conscious about medical equipment, and arrangements are made in advance with hospital staff, some assistive devices can be removed or rearranged during the photo session.

Often, a seriously ill child will need to be photographed in a hospital setting.

Greeting/Approach

Use your most genuine, upbeat, friendly greeting.

Lighting

Soft lighting works best for ill children. Extra effort should be made to secure natural settings for photos.

Sounds

If appropriate, try some fun music just to lighten up the mood.

Attention-Getter

Bright objects with happy sounds are good.

Props

When photographing a hospitalized child, you may wish to determine whether the hospital has a serenity garden. If the child is able to visit the garden, it can provide a beautiful location for portraits.

Children undergoing treatment are very susceptible to bacteria that can be found on props and stuffed animals. Use either props from the child's own room or sanitized studio props. Many young hospitalized cancer patients may be undergoing treatment that causes them to lose their hair. Be sure to address the possibility of hats in the pre-session interview.

Posing

Let the child select something out of her own environment or make a choice between some fun things you might have to offer. A young person might like to be photographed with a meaningful object that they will be able to write about in their journal or scrapbook.

Sitter's Focus

No special consideration is necessary.

Special Considerations

An ill child may be fragile or have fatigue issues. Following chemotherapy or other invasive treatment, a child may not be feeling very well. Allow the child to take extended breaks between poses, or leave the room if necessary. Consider returning when the child is having a better day.

Chapter 20

LEARNING DISABILITIES

THIS IS A BROAD DEFINITION FOR COGNITIVE DISABILITIES. Learning disability can be associated with a vast range of disorders including cerebral palsy and Down syndrome.

ROOM PREPARATION
Many of the more involved children exhibit a lack of self control. Create an uncluttered path, free of cords and cables. Protect the child—and your equipment—from harm.

SEATING PREPARATION
Check with the parent about this child's ability to sit in one place for very long.

WHAT TO EXPECT DURING A PHOTO SESSION
Discuss possible behaviors with the parent or care provider. The child's behavior may be totally unpredictable or perfectly acceptable.

Check with the parent about this child's ability to sit in one place for very long.

COGNITIVE OR PHYSICAL CONSIDERATIONS
This child could have both cognitive and physical limitations.

AGE CONSIDERATIONS
This child's abilities are more important to consider than age.

THE PHOTO SESSION
Location
Discuss the possibility of shooting on location. A low-functioning child or a very hyperactive child may be more comfortable at home.

Ryan rarely came up for air when he was diving in and out of the play balls in the therapy room. The good thing was that he was restricted to a small area with interesting props. Cerebral palsy is part of his diagnosis. Only one usable portrait (top) "surfaced" out of this entire roll of film!

Greeting/Approach

Use a friendly greeting. Be sure to ask beforehand about the child's comfort with touching.

Lighting

Natural lighting may be the best choice.

Sounds

Discuss the appropriateness of various sounds with the parent during the pre-session interview.

Attention-Getter

The parent will know what will attract their child's attention.

Props

Props may not be appropriate. The child's ability to hold an object will depend on the extent of the disability. Ask the parent.

Posing

Refrain from giving multiple directions. Be precise and don't chatter. To lessen any chance of confusion, discuss beforehand what you plan to do. Your posing opportunities will depend on the level of disability in the child. In the example shown here, Ryan would look up sometimes, but was constantly on the move.

Subject's Focus

Some children may be only mildly affected. With more involved children, catch a pleasant look or position when you can!

Special Considerations

Consider using an assistant to help with this child's sitting.

Chapter 21

MULTIPLE DISABILITIES

MULTIPLE DISABILITIES CAN INCLUDE ANY COMBINA-
tion of the five major disability categories listed in
the back of this book. Severely profound disorders
leave the child with very little ability of move on his own, talk or eat.
Attendants must regularly reposition these children because of their
inability to move themselves.

ROOM PREPARATION
Most of the photo venues for children with very low mobility will be
at their school, therapy center or home. Their wheelchairs are usual-
ly oversized to allow for stretching the legs and moving the child
within the chair.

SEATING PREPARATION
Discuss seating with the parent. Cognitive disabilities cover a wide
range of function. Extreme cases may best be photographed in bed.
Many are comfortable when supported by stuffed animals or pillows.

WHAT TO EXPECT DURING A PHOTO SESSION
Many children in this condition, no matter the age, are similar to a
very young infant.

Lauren's loving kiss from her mother as
Sally Harding captures the special
moment. Lauren is blind and developmen-
tally disabled in many ways.

COGNITIVE OR PHYSICAL CONSIDERATIONS
Do not anticipate compliance with your directives. Parents will be
most helpful in controlling the child's movement (as shown in the
photo on the facing page).

AGE CONSIDERATION
None.

Location

These children may be best photographed in their own environment. Sometimes a bed or beanbag chair is the best location for an extremely low functioning and immobile child. However, these children may do fine in studio if the atmosphere is quiet.

Greeting/Approach

Use a friendly greeting, as though you would expect to receive a response.

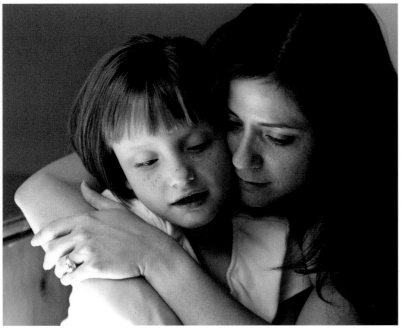

Her mom helped slow Scout down to capture this natural light portrait. Music was also used to help set a relaxed mood. Photograph by Sally Harding.

Lighting

Natural light will provide a softer look for this child. Use high speed film inside.

Sounds

Some special sounds may evoke a reaction (each child has his or her own favorite). The care provider will know what these sounds are.

Attention-Getter

The attendant will know if there are any special words or sounds to which the child will respond for the camera. There is generally some type of noisemaker in the therapy room that may attract the child. Lights are frequently used to attract attention and get a possible response. Check with the parent or care provider.

Props

Stuffed animals or pillows may be used for supporting the child. However, they may become a visual distraction. Drapes can be used to cover equipment or assistive devices.

Posing

Many severely affected children may not be able to respond to a photographer's prompt. Ask the attendant or care provider to move the child or adjust the pillows until the arrangement looks suitable for the photograph. If there is a lot of equipment and other paraphernalia in view, position the child in a clear area of floor or carpet, gain elevation and shoot down. Prepare to use draping or a handheld background.

Chapter 22

PSYCHOLOGICAL CONDITIONS

*T*HIS IS A GENERAL TERM FOR A CHILD WITH A MENTAL disability. Establishing a rapport with the child by explaining the process prior to the session may help avoid stress. Many mental conditions can be controlled with medications, but certain tendencies and characteristics remain. Included in this category are conditions such as bipolar, schizophrenia and conduct disorders.

Learn the extent
of the child's abilities
and patience
for sitting still.

ROOM PREPARATION
Clear the room of loose equipment and cords.

SEATING PREPARATION
Discuss your best options with the parents. Learn the extent of the child's abilities and patience for sitting still.

WHAT TO EXPECT DURING A PHOTO SESSION
You can expect anything. Have a thorough pre-session interview with the parent to determine this child's behavior.

MENTAL OR PHYSICAL CONSIDERATIONS
Expect mostly behavioral ramifications. Some physical and cognitive involvement may accompany a psychological disorder.

AGE CONSIDERATIONS
None.

THE PHOTO SESSION
Location
Consider a location shoot outdoors. Try showing the child engaged in an activity she really enjoys.

Greeting/Approach

Use a friendly greeting. Do not reach out to touch the child unless invited to do so.

Lighting

Some medications cause sensitivity to light.

Sounds

No special lighting consideration necessary.

Attention-Getter

No special consideration necessary.

Props

The use of props is not recommended unless specifically requested by the parent.

Posing

This child may not be able to follow directions.

Sitter's Focus

No special consideration is necessary.

Special Considerations

Allow the child to keep his or her distance. Take precautions with protection of equipment.

Vanessa was photographed while she was engaged in an activity she enjoys. Natural lighting was used for this shot.

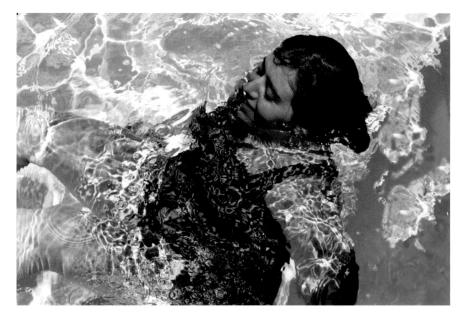

RESPIRATORY CONDITIONS

CONDITIONS INVOLVING RESPIRATORY ISSUES (BREATHING problems) include asthma and allergic reactions to pollens or chemicals. Asthma, a life threatening illness, causes airways to be narrowed because of inflammation. Recently, more and more children have begun to be diagnosed with this condition. Inflammation of the air passage can be triggered by stimuli such as dust, pollens, animal dander, smoke, cold air and exercise. Asthma attacks can vary in frequency and severity. Some children with asthma are symptom-free most of the time, with brief episodes of shortness of breath; others cough and wheeze without much relief and often have severe attacks after viral infections, exercise or exposure to irritants.

Sensitivity to odors, foods and pollens can be very serious. For instance, an extreme peanut allergy can produce an allergic reaction if a child even touches a product made with peanuts or comes in contact with any type of peanut residue—even on someone else's hands. Most sensitivities are not as extreme, but if it is learned that a child has allergies or respiratory problems, care should be taken to protect the child against an episode.

> Recently, more and more children have begun to be diagnosed with this condition.

● ROOM PREPARATION

If using the studio for your photo session, make certain it is clean and free of dust and odors. Do not leave any food or empty food containers lying around. Wash your hands thoroughly prior to greeting the child. If a child is severely affected by allergens, the parent may want to schedule the sitting at home where the environment is fairly safe. Do not bring dust-laden equipment (such as reflectors, lighting, etc.) that, when expanded, will spread dust particles around.

E. J. was photographed with his sister by Teri Vogeding.

SEATING PREPARATION
Use a seat that is not covered with a cushion or upholstery that could be full of dust particles.

WHAT TO EXPECT DURING A PHOTO SESSION
If a child has an asthma attack during the session, don't panic. The child or parent will usually be carrying the necessary remedies to aid in counteracting the attack. If nothing seems to be working, call 911 for assistance.

COGNITIVE OR PHYSICAL CONSIDERATIONS
These are generally normally-developing children. If a break is required due to symptoms, be patient. Crying or hearty laughing could bring on symptoms.

AGE CONSIDERATION
None.

THE PHOTO SESSION
Location
Avoid environmental irritants. A location shot on a windy spring day with lots of pollen in the air might not be a good choice for a child with asthma. Ask the parents about the child's specific sensitivities.

Greeting/Approach
Wash your hands thoroughly prior to shaking hands with a child who has severe allergies.

If a child has an asthma attack during the session, don't panic.

Lighting
No special lighting consideration necessary.

Sounds
Soothing music is good.

Attention-Getter
No special considerations except to avoid irritants. For instance, do not wave anything around that is dusty. Stuffed animals also contain dust and could be a potential hazard. Use props that are clean, have no apparent odor and are not laden with loose particles. Balloons, for instance, may have a strong rubber/latex odor. Always clean any prop between use by different children.

Stuffed animals also contain dust and could be a potential hazard.

Props
Make certain props are sanitized and free of germs. These children are susceptible to infection.

Posing
No special consideration necessary.

Sitter's Focus
No special consideration necessary.

Special Considerations
The child may be experiencing a temporary, but extremely delicate or sensitive physical condition. If the child is seriously involved, allow plenty of time for rest breaks.

SPINA BIFIDA

S PINA BIFIDA IS A CONDITION IN WHICH PART OF ONE OR more vertebrae fails to develop completely, leaving a portion of the spinal cord unprotected. Some children have minimal or no symptoms; others are weak or paralyzed in areas reached by nerves below the level of the defect. Recent medical technology has made surgical correction of this condition possible in most cases—often prior to birth.

ROOM PREPARATION
If the child is in a wheelchair or walks with assistance, prepare the way by clearing cords, lighting equipment or platforms.

Bobby sits in a suitcase cushioned by a blanket for this portrait by Jennifer Collins.

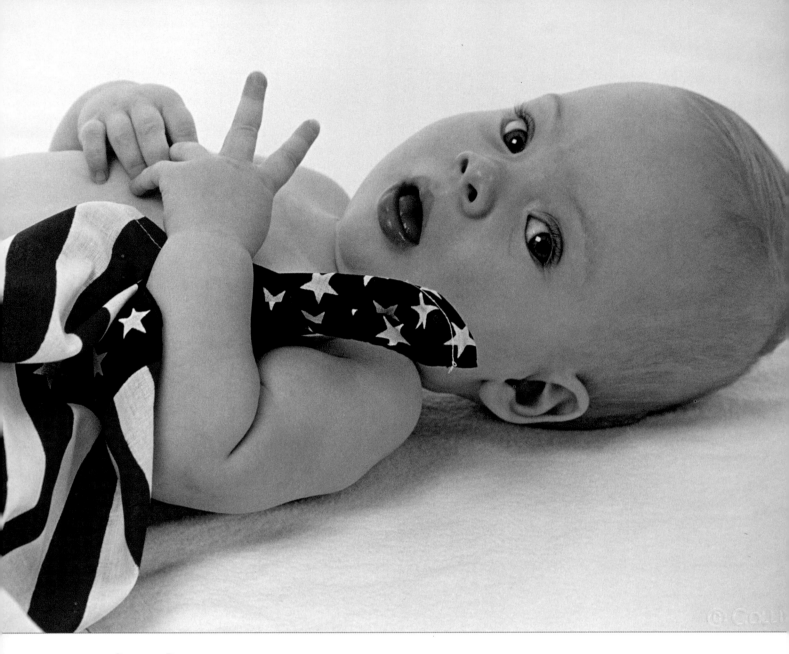

SEATING PREPARATION

Discuss seating with the parents. Keep in mind that these young people can be heavy to lift without assistance. A soft chair or beanbag chair could be an acceptable alternative to a wheelchair. During pre-session interview, ask about possible location of a urine bag that might be attached to the wheelchair.

WHAT TO EXPECT DURING A PHOTO SESSION

These children are generally quite social. They will respond well to suggestions for posing.

COGNITIVE OR PHYSICAL CONSIDERATIONS

Special care should be taken with the back and spine area. In some cases, operations and the condition itself can cause this area to be

An American flag bandanna was used as a prop for this portrait of Bobby—who spontaneously made a "peace" sign as if on cue! Photograph by Jennifer Collins.

extremely sensitive or painful. Parents may use various cloths or pads to absorb bodily fluids with young infants.

AGE CONSIDERATIONS
Younger children may be undergoing operations.

THE PHOTO SESSION
Location
Either indoor or outdoor shoots are okay.

Greeting/Approach
Use the greeting of your choice.

Lighting
No special lighting consideration is necessary.

In this uncluttered portrait of Bobby, Jennifer Collins used a half-barrel as a support. She placed him on a clean white background and kept him small in the frame for a perfect portrait of a sweet little boy.

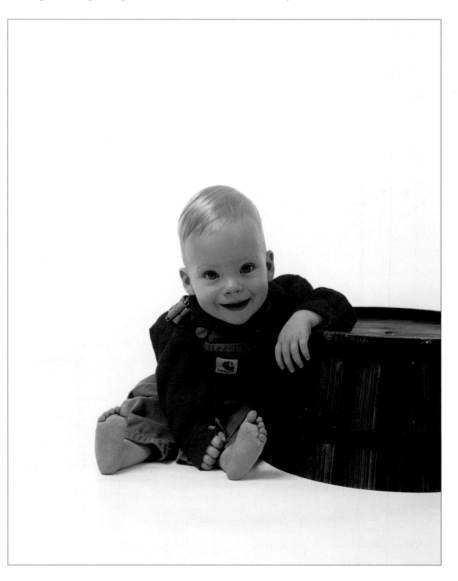

Sounds
No special recommendation.

Attention-Getter
Select something that is age-appropriate.

Props
Consult the parent or child for things that work or will be of special interest to the child. Suggest bringing something from home such as a musical instrument or sports item that will represent an activity that fosters self-esteem.

Posing
Ask for input from the parent and child. The example of Barry (shown below) shows a delightful sitting with him in his "punk" pose. Barry is an actor.

Sitter's Focus
No special considerations are necessary.

Special Considerations
Always tell the child what you are going to do prior to moving him. Learn if the child can move himself or if he needs assistance. Always be mindful of the sensitive spinal area.

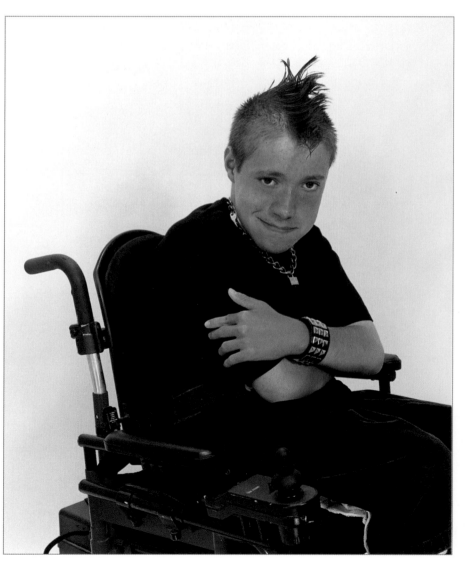

Barry adopted a punk pose for this portrait photographed in the studio by Sue Cassidy at The Picture People.

TRAUMATIC BRAIN INJURIES (TBI)

If impulsive behavior

is an issue,

eliminate items from

reach of the child.

*D*AMAGE TO THE BRAIN CAN CAUSE A WIDE VARIETY OF disabilities. "Traumatic" implies an injury caused by an accident involving the head. Behaviors can include becoming easily distracted, apathy, indifference and a disregard for the consequences of their behavior. These children may show inappropriate euphoric reactions, vulgarity and rudeness. Some children may have no verbal communication. Work with the parent to form some line of communication with a child who is unable to speak. These children are at risk for seizure activity.

ROOM PREPARATION

If impulsive behavior is an issue, eliminate items from reach of the child. Protect valuable equipment. Have the parent or care provider remain in the room. An assistant may also be a valuable asset with inappropriately active children with TBI.

SEATING PREPARATION

Carefully discuss seating with the parents. A chair with arms or a large cushion on a platform may be a good choice.

WHAT TO EXPECT DURING A PHOTO SESSION

Expect anything. Thoroughly discuss all possibilities with the parent.

COGNITIVE OR PHYSICAL CONSIDERATIONS

Some children may have a lack of inhibition or boundary awareness and they most often have difficulty following directions.

AGE CONSIDERATIONS

None.

Location

Either a studio or location shoot outside is okay. Take precautions with lighting that could trigger a seizure in certain children.

Greeting/Approach

Use your best upbeat greeting.

Lighting

Some of these children are at risk for seizures. Some lighting, such as strobe or flickering fluorescent, can trigger seizures.

Sounds

No special sound consideration is necessary.

Attention-Getter

Many children with more serious brain injuries will respond to certain items or phrases. Consult with the parent or caregiver about preferences.

Props

The child may respond well to a favorite item. Ask the parent to bring in some of the child's favorite objects. Many children with TBI have a special interest in sports or celebrity figures that were favorites prior to their injury. Try to incorporate their unique interests in the photograph, as exemplified to the right with the photo of Tommy.

Sitter's Focus

No special consideration is necessary.

Special Considerations

If it is an issue, take care with the child's delicate or sensitive physical condition.

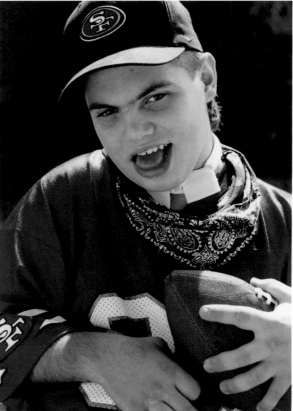

Tommy wears a bandanna as an assist for drooling. In the top photo, photographer Sally Harding helps Tommy prepare for the photograph. As a result of the pre-session interview, she asked Tommy's mother to dress him in his favorite football shirt and hat. To avoid soiling the shirt, Tommy wore a "cover shirt" that was placed on back to front with the top buttoned. This protected his favorite shirt from becoming soiled prior to photo time.

TUBES AND MEDICAL DEVICES

*C*HILDREN WITH A NUMBER OF DISABILITIES MAY ALSO HAVE breathing or feeding tubes in place. The parents and child may want to conceal these, or may be perfectly fine with leaving them visible in the portraits.

ROOM PREPARATION
Clear the room of cords and clutter for easy access.

SEATING PREPARATION
If the child is in a room with a lot of other assistive technology, find a clear area of the floor, elevate the camera and aim down with the camera (or have someone hold a manageable backdrop).

WHAT TO EXPECT DURING A PHOTO SESSION
Arrange poses that downplay the medical equipment.

COGNITIVE OR PHYSICAL CONSIDERATIONS
The function of these children can cover a vast range of ability and limitation.

AGE CONSIDERATIONS
None.

THE PHOTO SESSION
Location
Lots of bulky equipment is easier to manage indoors.

Greeting/Approach
Use your friendliest greeting, calling the child by name.

Lighting

No special consideration is necessary.

Sounds

Sounds may be distracting. Soothing music, however, may be calming.

Attention-Getter

When attempting to get the attention of a child who is hooked up to tubes and other medical devices, take care not to stimulate them to the point where connections will be impaired or even accidentally pulled out.

Props

Seek out the child's favorite items.

Sitter's Focus

No special consideration.

Special Considerations

Take care when you are navigating around with cords, lines, tubes, etc. Consult with the parents about the possibility of removing the devices temporarily. Always use caution and leave the decision and acts of removal and reconnection entirely to the parent.

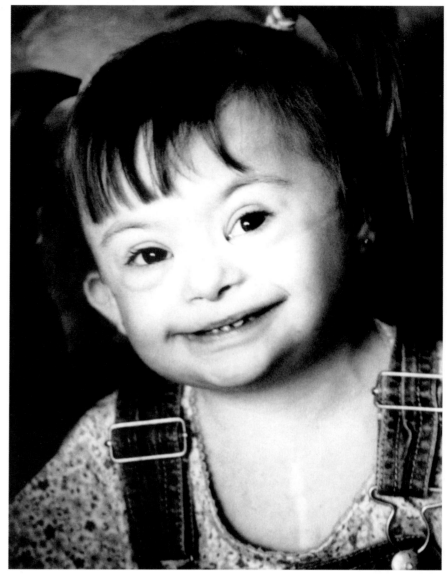

Katie had pneumonia when Sally Harding took photos of her. The slight indentation on the side of her face is a tell-tale reminder of the tube from the breathing apparatus that was temporarily removed for the photo. Katie passed away a few days after the photo was taken. Katie's mom went back and forth between tears and laughter as she viewed the proofs. She loved every one of them. "You have really captured Katie," she said. "Each picture shows a unique aspect of Katie's personality. They're the best I've ever seen of her. I'm so glad you were able to take them."

Chapter 27

SCHOOL OR
CARE CENTER PHOTOGRAPHY

AKING INDIVIDUAL PHOTOGRAPHS OF CHILDREN AT A special school for kids with disabilities is a challenging job! It's an effort that is extremely taxing, both physically and emotionally. As you take their pictures, each child can be vastly different from the one before—and the one that will come after.

Keith Wyner photographed Lilli, who has developmentally delayed cerebral palsy, while she sat on a bench in her school's garden.

Depending on the school, the desires of the parents and staff may also come into play. Some children may be confined to a beanbag chair on the floor, unable to move. However, the parent may want staff to remove a trach tube from the child's throat and then cover the connective device with a scarf or cloth. Of course the oxygen equipment should be out of the lens' range also (unless otherwise requested by the parent or caregiver).

If the child uses a wheelchair but the parent does not want it to show, patience must come into play while the staff helps "transfer" the child to an appropriate seating arrangement. Is an appropriate seat readily available? If you are photographing at an institution for the first time, discuss all these options prior to the day of the sittings. Visit the school to observe the children and conditions for yourself prior to picture day.

Most schools focus their service on a certain classification of children—high function, middle range and low function. High function may sound like an easier assignment than low function, but it could include children with anti-social behaviors and unexpected actions. In contrast, the school with low-function children may have only those boys and girls who are confined to wheelchairs, beds and beanbag chairs. Here again, a prior visit will help you determine needs (including your own emotional preparation).

Tiffany, who has Cornelia de Lange syndrome and cerebral palsy, was photographed by Keith Wyner while she sat in her wheelchair at school.

From the Photographers . . .

"Students do not always behave or look their best, being upset or distracted with the sensory overload or not being able to follow or understand the instructions of the photographer. For some students, 'Look at the camera and smile' is beyond their comprehension and is not what they have in mind even if they do understand. For low-verbal and autistic students, photo schedules that involve their school activities may reduce their anxiety about what will be happening that day. It helps to reduce their tantrums and can improve their behavior."—Keith Wyner, photographer and teacher of special needs children

Here are some tips and tricks used by some special needs school photographers:

1. Use a child-size inflatable armchair for seating the children.
2. Bring about two yards each of different colors of faux suede material to use as drapes. This can be used in front of the child to cover straps, trachs, or other assistive device, or may be held as a portable backdrop by a person standing behind the subject (this person can also help to support the child). Be prepared for soiling to occur.
3. A single step can offer a good seating platform.

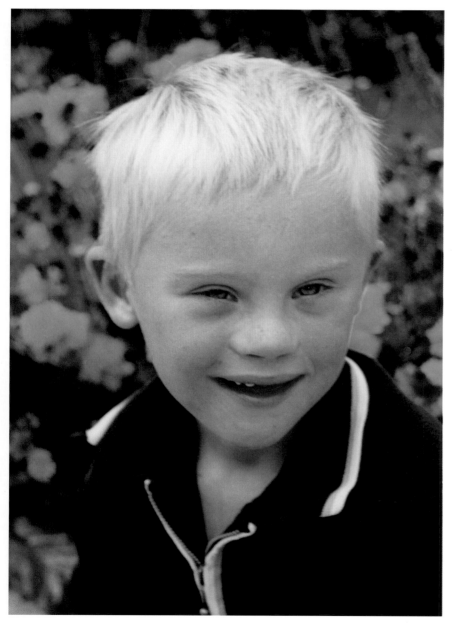

4. Beanbag chairs are good. If you bring your own, use one with a plastic surface that can be cleaned and disinfected.
5. For certain schools, have a mock or "retired" camera on a tripod for the children to look through and "take pictures" with before your session. Such extra maneuvers may save time and frustration in the long run.
6. Try using a camera baffle (described on page 108).
7. Go easy on yourself. If you don't have an assistant (although one is highly recommended) or don't have the use of a helpful school staff member, consider *wearing* your attention-getter (see ideas on page 109).

Austin was photographed by Keith Wyner while sitting on a bench in the school garden.

BAFFLES AND ATTENTION-GETTERS

S OME CHILDREN WITH SPECIAL NEEDS MAY TURN AWAY when spoken to or when they see a camera pointed at them. If the child seems resistant, don't try to force a smile or frustrate yourself and the child by insisting on eye contact. Instead, experiment with one or more of the ideas listed below.

BAFFLES

Certain children prefer to look at an inanimate object rather than a human. Make a lightweight baffle to fit around the lens of your camera. This will conceal you and your camera while fascinating your subject. This tactic may even provoke a smile.

To create a baffle, use an appropriate ready-made poster (these are available for a reasonable cost at holiday time in the 99¢ and discount stores) and cut a hole in a likely place in order to accommodate the lens. The poster should be lightweight but strong enough to hold up on its own. A sheet of foamcore (from a craft or art store) is extremely sturdy, yet lightweight, and can be used as a backing to improve stability.

You can use children's coloring books to get image ideas for creating a clown, fireman, cartoon character or cowboy baffle. Cartoon characters can work well because their noses are big and black—making them ideal candidates for a "lens" nose.

A piece of foamcore board can be decorated with a happy illustration that accommodates the camera's lens. This baffle can be useful with children who find the camera intimidating.

ATTENTION GETTERS

Don't wear yourself out by trying to attract attention with a "squeaker" toy or hand puppet. Preserve your energy by *wearing* your attention-getter.

Find hats on sale on discount store clearance shelves or at thrift stores. Some craft stores have large straw hats as shown to the left. Adapt them to suit your purpose. Look for battery-operated glowing balls, plentifully available at Halloween and Christmas time. Otherwise, check your local novelty and magic store. Sew them into the hat or glue them on, whichever is easiest. Discount stores have plastic and rubber bugs that lend themselves to creating "creepy-thing hats" (use heavy-duty, all-purpose craft glue to secure the bugs).

Most children are not intimidated by a brightly colored bug. But ask the parent, just to make certain the child won't recoil in absolute terror. Party stores may also have those bonky "martian" antennae that fit around the head or can be sewn into a hat.

Bubbles are a great distraction for children. They are great for photographers to use as an attention-getter, mainly because they come down so slowly and are almost invisible. Look closely at the group shot on page 3; one bubble can be detected in the lower right-hand corner of the photo.

SImple devices, like an elaborately decorated straw hat or a bouncing pumpkin headband, can be helpful for attracting the child's attention.

An old trick is to place a slit in a red foam ball that can be easily affixed to your nose. Don't get frustrated, though, if a child appears not to notice a nose that you were not given at birth.

Don't feel rejected if a child with certain disabilities completely ignores your normally "great stuff" attention-getter. Some children with autism, for instance, may gloss over any attempt to get them to look at you. Find out what works with different children. Be prepared to drop any ploys and just follow the child around as he finds his own interests.

Many kids like to play dress-up, and great finds can be had at thrift stores. Purchase a frilly dress, wash it thoroughly and cut a long opening in the back and sleeves. Secure it with ties (like those on a hospital gown). You can do the same with clothing for boys. Make sure to wash each garment thoroughly between uses to avoid passing germs between children.

Chapter 29

BASIC SIGN LANGUAGE

S IGN LANGUAGE IS NOT AS "FOREIGN" AS IT MAY APPEAR. When considered individually, most gestures are a natural physical interpretation of the thought you would like to convey. You don't have to master ASL (American Sign Language) to communicate with many special children who have limited verbal skills. (Also, the child does not have to be deaf to benefit from hand signals.) Don't be shy. Don't hesitate. If you can't remember these, make up your own signs as you go. When you perceive that hand movements might work better than words as communication, try gesturing! Your considerate efforts will be appreciated.

Hi, Hello

PICTURE, PHOTOGRAPH

YOU

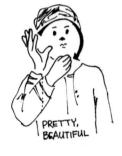
PRETTY, BEAUTIFUL

SMILE

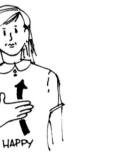
SIT, BE SEATED

HAPPY

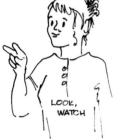
LOOK, WATCH

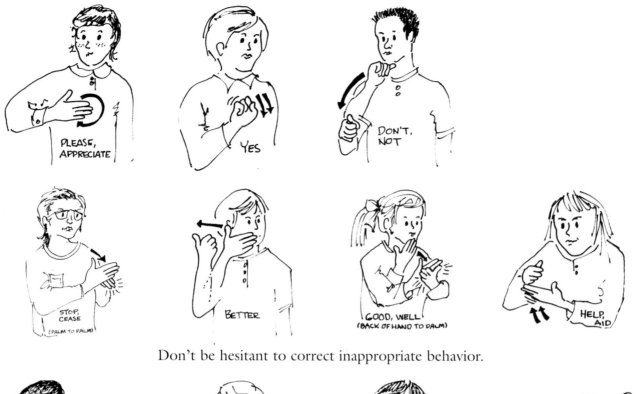

Don't be hesitant to correct inappropriate behavior.

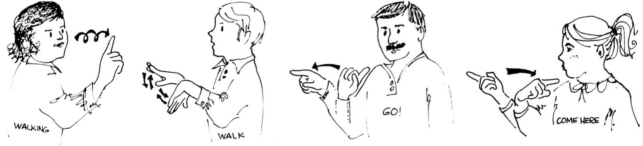

Don't try to gesture complete sentences. Ad-lib—a child will appreciate your efforts to communicate.

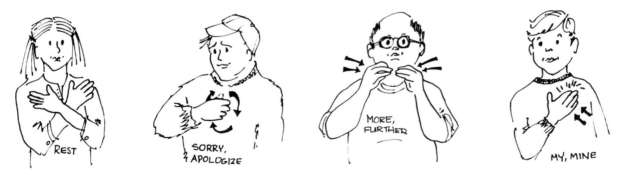

Provide frequent rest periods. Praise the child frequently. Use "thank you" often!

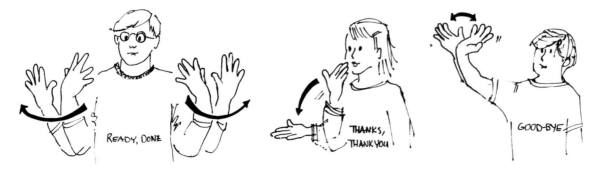

Chapter 30

ADDITIONAL RESOURCES

YOU'VE PROBABLY LEARNED BY NOW THAT THE KEY TO success in photographing special needs children is to learn as much as possible about the child and his condition. The following resources will provide additional information on the conditions discussed in the previous chapters, as well as additional conditions you may encounter and children's health issues in general.

General

 The Picture ME Foundation serves children with special needs through photography and therapeutic scrapbooking. Visit www.pictureme.org for more information on photo clinics, exhibits and pediatric programs in hospitals and camps.

Ability First
(Established as Crippled Children's Society)
www.abilityfirst.org

Office of Special Education and Rehabilitative Services, Switzer Bldg., Room 3132, 330 C Street, SW, Washington, DC 20202-2524

National Information Center for Children and Youth with Disabilities, P.O. Box 1492, Washington, DC 20013, (800) 999-5599, email: NCHCY@aed.org www.nichcy.org

National Easter Seal Society
230 West Monroe Street, Suite 800
Chicago, IL 60606
www.seals.com

Amputation
Amputation Home Page
www.eatonhand.com/clf/clf450.htm

Angelman Syndrome
www.autism.org/angel.html

Arthritis
www.arthritis.org

Asperger's Syndrome
www.autism.org/asperger.html

Asthma, Allergies
American Academy of Allergy
www.aaaai.org

Association for the Care of Children's Health (ACCH), 1900 Mantua Road, Mount Royal, NJ 08061, (609) 224-1742

Attention Deficit Disorder (ADD)
National Attention Deficit Association
www.add.org

Autism
Autism Society of America, 7910 Woodmont Avenue, Suite 650, Bethesda, MD 20814-3015
www.autism-society.org
Center for the Study of Autism
www.autism.ort/contents.html

Birth Defects
March of Dimes
www.modimes.org

Blindness
American Council for the Blind
www.acb.org

American Foundation for the Blind
www.afb.org

Blind Children Center
www.blindcntr.org/bcc/

National Federation of the Blind
www.nfb.org

Cancer
National Cancer Institute
www.nci.nih.gov

Chronic Illness
Center for Children with Chronic Illness and Disability, Division of General Pediatrics and Adolescent Health University of Minnesota, P.O. Box 721, 420 Delaware St., Minneapolis, MN 55455

Cerebral Palsy
United Cerebral Palsy Association
www.ucpa.org

Cystitis
Interstitial Cystitis Association
www.ichelp.org
800-HELP-ICA

Deafness
National Association of the Deaf
www.nad.org

Disabilities
National Maternal and Child Health Clearinghouse, 2070 Chain Bridge Road, Suite 450, Vienna, VA 22182

Down Syndrome
National Down Syndrome Society
www.ndss.org/main.html

National Association for Down Syndrome
www.nads.org

Ehlers-Danlos Syndrome
Ehlers-Danlos National Foundation, 6399 Witshure Blvd. Suite 203, Los Angeles, CA 90048
www.ednf.org

Epilepsy
Epilepsy Foundation
www.efa.org (local affiliates listed on website)

Hydrocephalus
www.hydroassoc.org
888-598-3789

Muscular Dystrophy
Muscular Dystrophy Association
www.mdausa.org

Osteogenesis Imperfecta (brittle bones)
Osteogenesis Imperfecta Foundation
www.oif.org

Rett Syndrome
www.autism.org/rett.html

Spina Bifida
Spina Bifida Association of America, 4590 MacArthur Blvd., NW, Suite 250, Washington, DC 20007-4226
www.sbaa.org

Chapter 31

DISABILITY CATEGORIES

*A*LTHOUGH STATE AGENCIES AND CARE FACILITIES located worldwide do not categorize information in the same manner, the following titles are globally understood and provide a way to allow organized descriptions for serving children with disabilities or serious illness. Disabilities are classified into one of five primary categories:

1. Cognitive
2. Mental
3. Sensory
4. Physical
5. Medical

If a parent brings you a child with a disorder that is not specifically mentioned in this publication, learning whether the condition is mainly cognitive, mental, physical, sensory or medical (or a combination of two or three primary categories) will provide direction for the suggested approach in providing services. The pre-session interview should provide enough clues to make a determination as to the expected behavior or physical condition of the child.

Always keep in mind that, no matter what the disability, you must respect and treat all the children with kindness and as individuals, with distinct talents and abilities—not just the disabilities that are most apparent.

COGNITIVE

Cognitive disorders refer to the ability to learn new information, remember that information and then process the learned information when taking it into a different situation. The child's emotional

The pre-session interview

should provide enough clues

to make a determination

as to the expected behavior . . .

responses to various situations may differ from what is expected. This child may have difficulties with abstract concepts.

As an example, if you prompt the child to think of a "summer day," he will have difficulty translating that directive. However, if a brightly colored sand pail and shovel were shown—providing the child has had experience with these items—you will have more success in achieving the desired reaction. Location shoots at home are very appropriate for the child with a cognitive disorder.

MENTAL

Mental impairments may include mental illness such as schizophrenia, bipolar, clinical depression, obsessive compulsive disorders and high levels of anxiety, which are usually controlled with medication. Provide the parent with information about what you will be doing and the equipment you will be using. The parent needs to, in turn, prepare the child prior to the photographic activities to alleviate possible anxiety.

Consider having the child watch you work with a Polaroid or a dummy flash camera to demonstrate what will take place. Generally, props are not recommended for the child to hold unless deemed appropriate and approved by the parent. Outdoor venues or sittings in the home environment are very appropriate and highly recommended for a child with mental issues.

SENSORY

Sensory issues refer to any impairment of one or more of the senses—touch, sight, hearing, smell and taste. Autism, for instance, (though highly complex) is classified as a sensory disorder. Children with sensory disorders can be defensive to touch. They may not want to be touched or even have their immediate space invaded. Some children are very sensitive to either light or sound.

However, other children in this category may love to be hugged. Expect a wide variety of responses. For instance, a child with sensory disfunction may not like fuzzy things but might love the feel of sandpaper. Another may recoil at the sight of fake green turf. Air blowing from a fan or air conditioning vent may be very disturbing to them.

When sensory conditions are involved, take careful notes during the pre-session interview—especially regarding touching and other sensory stimuli such as sounds, noises, and lights that will be present during the photographic session. Because some children have difficulty processing information, it may take a long time for the child to respond to a directive or to stimuli you are presenting, if at all.

Consider having the child watch you work with a Polaroid or a dummy flash camera . . .

PHYSICAL

Children with physical impairment may exhibit minor or highly significant physical limitations. Movement may be restricted or even painful. A wheelchair or other assistive device may be a necessary part of this child's life, although it does not necessarily need to be part of the photo. Ask about preferences and ways to "transfer" (the correct term to use) the child to other seating arrangements. Physical impairments are often part of disabilities such a neuromuscular, cerebral palsy, muscular dystrophy, or orthopedic impairments.

MEDICAL

The medical classification includes illnesses such as cancer, HIV/AIDS, anemia and diabetes. A medically fragile child may have fatigue or nausea issues or may require a breathing device, nose feeding tube or other assistive medical equipment.

Chapter 32

LEARN THE LINGO

*L*ANGUAGE IS A POWERFUL TOOL—IT CAN MAKE OR BREAK a relationship. It can move mountains, or move someone to tears. Appropriate language is not about being "politically correct;" it is a reflection of our attitudes, awareness and humanity. Be sure to send the right message!

This reference information is intended to reflect, promote and exemplify people with disabilities. Read carefully; many words are acceptable, but other words are "preferred." For instance, "person with a disability" is preferred over "disabled person," "handicapped;" or "cripple." Say "She has multiple sclerosis," rather than "She is afflicted (or 'was stricken') by the condition." In other words, place the "person" first, then consider the disability. Think of how you, yourself, would like to be addressed. Abbreviations such as "CP" for cerebral palsy are okay if you are certain you are using them correctly and that the person to whom you are speaking understands you.

ADA—Americans with Disabilities Act (1994). This mandate requires that people who provide services may not discriminate against persons with disabilities.

"Afflicted"—Alternative: "has . . ." or "is affected by . . ."

Aicardi Syndrome (cognitive and physical)—Aicardi syndrome is a rare genetic disorder affecting only females. This syndrome is characterized by "markers" such as an inability for the left brain to communicate with the right brain, infantile spasms, mental retardation, lesions of the retina of the eye, and other types of defects of the brain. (See page 54 for additional information.)

Allergies (medical)—Children who are highly allergic could have a high sensitivity to dust, odors or foods. This is a good excuse to give your studio a thorough head-to-toe dusting and cleaning. Do not leave food around or have candy out. Children with severe peanut allergies, for instance, could have a serious reaction to your handshake if you have just eaten a peanut-laden candy bar. (See page 94 for additional information.)

Amputation (physical)—Some birth defects cause a child to be born with an incomplete or missing limb. Other children may have lost an arm or leg because of disease or accident. Use sensitivity to position the child. There may (or may not) be a

request to pose in a way that would not show, or would lessen the visibility of the amputated limb. Ask about preferences. (See page 41 for additional information.)

Angelman Syndrome (sensory)—Angelman syndrome is a genetic disorder caused by abnormal gene function and is sometimes misdiagnosed as autism. Angelman syndrome affects males, females and all racial/ethnic groups equally. They have movement or balance disorder and behavioral uniqueness with any combination of frequent laughter/smiling, apparent happy demeanor and an easily excitable personality. Some children experience seizures, physical deformities, drooling, hyperactivity or other abnormalities.

Arthritis (physical)—Arthritis is an inflammation of the joints. Symptoms of arthritis include swelling, tenderness, pain, stiffness or redness in one or more of the joints. Symptoms may also be accompanied by fatigue. Use sensitivity to position and pose the child. Parents may request to pose in a way that would not show, or would lessen the visible effects of the disease. (See page 64 for additional information.)

Attention Deficit (Hyperactivity) Disorder (ADD or ADHD) (cognitive)—Attention deficit disorder is characterized by the child exhibiting inappropriate attention, impulsivity, and hyperactivity. Children with this disorder may appear not to listen to directions or not to have heard what was said. The child may have difficulty sitting still or may be very impulsive. The child may have limited capacity to focus or remain still in one position or may not respond to cues or direction for posing. Maintain good eye contact. If possible, have the child repeat what you have asked them. An assistant is recommended. Consider the possibilities of a home or location shoot. (See page 44 for additional information.)

Autism (sensory)—Autism is a condition whereby children exhibit symptoms of self-absorption, inaccessibility, the inability to relate to others and highly repetitive behaviors. This child may be fearful, withdrawn, noncommunicative, may have repetitive or unusual behaviors, and may be limited in their ability to respond to verbal cues. The child with autism may behave in a compulsive and ritualistic way and usually fails to develop normal intelligence. May have limited ability to smile. Explain the process beforehand to avoid any unnecessary apprehension or fear. Consider possible home or location shoot. With an autistic child, also watch for cognitive or mental issues such as obsessive-compulsive disorder. An assistant is recommended to help create a successful photo shoot. (See page 47 for additional information.)

Binder's Syndrome (physical)—This is a birth defect affecting the nose.

Bipolar (mental)—Manic-depressive illness is also called bipolar disorder and is a condition in which periods of depression alternate with periods of excitement. Typically, this condition does not begin until the child reaches teen years. Medication is generally used to stabilize the bipolar individual.

Blindness (sensory)—Blind children and those with limited sight may need verbal cues for your directions. Always stay within their vision when you are speaking to them. (See page 51 for additional information.)

Brittle Bones (physical)—*See* Osteogenesis Imperfecta.

Burns and Birth Marks (physical)—A child who has experienced severe burns may be scarred emotionally as well as physically. Special makeup can cover scars and blemishes, but natural lighting may be your best friend for photographing children with large visible scars.

Cancer (medical with possible physical ramifications)—Child may be fragile or have fatigue issues. If the child has no hair, be direct but considerate in discussing options. A selection of "kid" hats may be a useful addition to your treasure chest of props. Be mindful that items are sanitized and will not carry germs that could cause infection to these children with compromised immunity systems. (See page 85 for additional information.)

Cerebral Palsy (CP) (physical with possible cognitive and medical considerations)—Cerebral palsy is a condition that affects muscle control. Symptoms range from simple clumsiness to multiple handicaps. Children with this condition can have normal intelligence but may have limited ability to move or pose. Many are confined to

wheelchairs. There may be balance issues or jerking movements. Sometimes spontaneous movement may be induced by emotions such as joy or fear. Prepare to use multiple photo frames. Work quickly; these children tire easily. Consider a home or location venue with a pleasant background. A pleasant facial expression by these children may be problematic; discuss prop or "baffle" options with the parent to distract the child's attention from your photo equipment and activities. (See page 57 for additional information.)

Chemical Sensitivity or Allergies (sensory)—Some children are highly sensitive to certain smells or foods, even through touch. Refrain from wearing scented products, using sprays or chemicals (magic markers and certain types of paper). Make certain the odors from new lights are completely "burned off" and no longer emitting smoke. These children may have fatigue issues. Carefully discuss options with the parent. (See page 94 for additional information.)

Cleft Lip and Palate (physical)—Facial abnormalities can include a cleft lip (incomplete joining of the upper lip, usually just below the nose) or palate (abnormal passageway through the roof of the mouth into the airway of the nose). Cleft lip and cleft palate usually occur together and can affect appearance as well as eating and speech. Surgery may correct the problem. (See page 81 for additional information.)

Cognitive (often accompanied by physical limitations)—Cognitive deficiencies refer to mental retardation. Mental retardation can range from mild to severe cognitive dysfunction. A child with cognitive problems may have limited ability to follow directions, so keep your requests simple and concise. Abstract ideas may be difficult to "see" in this child's mind without an actual "picture" (such as "a happy family"). Use concrete suggestions and show pictures or actual objects to induce reactions. The parent or an assistant may be useful in providing direction for a child who has low cognitive function or exhibits socially inappropriate behavior. (See page 62 for additional information.)

"Confined"—Alternative: "uses a wheelchair" or "works from home."

Connective Tissue (and/or Bone) Disorder (physical)—There are many types of connective tissue disorders that can affect the physical appearance of a child. With some types, the skin and even muscles may be too tight (creating small chest cavities and not allowing limbs to fully extend). With other variations of the disorder the skin may stretch very easily, to the point of hanging in loose folds. (See page 64 for additional information.)

"Crazy"—Alternative: "has a mental illness" or "has a mental impairment."

"Crippled/cripple/crip"—Alternative: "has a physical disability or mobility impairment;" "is a person with a physical disability."

Cystic Fibrosis (medical)—Cystic fibrosis is a disease characterized by abnormal secretions that affect primarily the lungs, pancreas and digestive tract. A medical device or nasal prongs may accompany this child to assist breathing. There may be a significant amount of coughing. Insufficient amount of oxygen may make the fingers clubbed and the skin bluish. With teenagers, there may be limited endurance. Protect this child against infection.

"Deaf and Dumb," "Deaf Mute"—Don't use these terms. Instead, say, "He has a hearing impairment" or "He communicates with sign language."

Deafness and Blindness (sensory)—Rely on the parent or care provider for communication. Inquire about using tactile cues for posing. (See pages 51 and 67 for additional information.)

Deafness or Hearing Impairment (sensory)—To communicate, use and interpreter, if available. Alternately, you may use visual cues for posing such as a hand signal or written sign. If the child reads lips, make sure to stay within the line of their vision when speaking. Do not cover your mouth or put anything in your mouth—such as a pen or pencil—when speaking. (See page 67 for additional information.)

"Deformed"—Alternative: "has a disability or an impairment."

Depression (mental)—Depression is a psychological condition characterized by prolonged sadness. Symptoms can include the inability to concentrate, anxiety, low self-esteem and apathy. A child may have limited ability to respond to cues, smile or pose. (See page 92 for additional information.)

Developmentally Disabled (DD) (global term)—Developmental disability is a catch-all term for children who may have physical, cognitive or sensory limitations or delayed development. This child may not have hit the "milestones" generally reached by other children who are the same age. The child may have a limited ability to follow cues. They may have difficulty with attention span or posing in one place for very long. An assistant may be helpful in working with this child. (See page 69 for additional information.)

Diabetes (medical)—The diabetic child may have fatigue issues. Be aware of signs of insulin reaction, which could cause the child to suddenly become quiet or disobey, sweat or tremble. Make certain a bathroom is nearby and that the parent or child knows where to locate it.

Down Syndrome (physical and cognitive)—Children with Down syndrome have delayed physical and cognitive development. Infants with Down syndrome tend to be quiet, rarely cry and have lax muscles. The average intelligence quotient (IQ) in a child with Down syndrome may be about half that of other children in the same age bracket. Physical factors can include a small head, slanting eyes, short nose, enlarged tongue, small low set ears, short fingers, heart defects and hearing loss. (See page 71 for additional information.)

Drooling (symptom)—Children with conditions such as Down syndrome, brain abnormalities/injuries, cerebral palsy and others may show symptomatic drooling or bubble blowing, even to the extent that the clothing could become soaked. Encourage the parent to dress the child in a "cover shirt" that can be removed just prior to the shoot. Keep a box of tissue close by if drooling is anticipated. Actually, it's a good idea to always have tissues within reach.

Dwarfism (physical)—Dwarfism is a physical condition where growth hormones or enzymes are deficient, causing abnormally slow growth and short stature. There are various causes of short stature. Mucopolysaccharidoses, for instance, are hereditary disorders that result in a characteristic facial appearance and abnormalities of the bones, eyes, liver and spleens, sometimes accompanied by mental retardation. Do not use the term "midget" to describe this child.

Facial Deformities (physical)—Some disorders will cause deformities to the face that may include cleft lip/palate, burns and a variety of other disfigurements.

Fetal Alcohol Syndrome (FAS) and Fetal Alcohol Effects (FAE) (cognitive and physical)—Drinking alcohol during pregnancy causes this disorder and can result in a variety of defects. The affected child can have growth retardation, facial defects, a small head and abnormal behavioral development. Mental retardation is a highly likely component with FAS. Children with FAE are not as severely affected, but may have some facial abnormalities or other disability.

Ehlers-Danlos Syndrome (mostly physical)—A rare hereditary connective tissue disorder that can result in unusually flexible joints, very elastic skin and fragile tissues. Flexibility tends to decrease over time. However, anticipate that this child may be somewhat fragile. If on location outside, do not encourage daring activities such as climbing trees or jumping from rock to rock. With injury, severe bleeding could occur and create large wounds and scars. Some children may develop a humpback with an abnormal curve of the spine or could have flat feet. (See page 75 for additional information.)

Epilepsy (medical)—Epilepsy is a disorder characterized by abnormal electrical impulses in the brain that lead to seizures. Seizures may range from mild to severe. Seizures can accompany a variety of disabilities. Flashing lights have been known to induce seizures. If on location, watch for extreme light/dark situations such as clouds blocking the sun or the flickering of sun and shadow when under trees. Consult with parent and consider natural lighting. (See page 78 for additional information.)

Graves' Disease (physical)—Bulging eyes, common in the adult form of the disorder, also occur in newborns.

"Handicapped"—Alternative: "is physically or developmentally challenged" or "has a disability."

"Hare Lip"—Use the term "cleft lip" instead.

HIV/AIDS (medical)—Pre-plan the session to avoid tiring the child. If planning the session for outside, make careful arrangements with the parent to facilitate easy transportation.

Hydrocephalus (physical)—Hydrocephalus is an abnormal enlargement of the ventricles (spaces in the brain). When the brain's fluid can't drain, pressure inside rises, causing swelling and, in some cases, an abnormally large head (mainly in newborns). This disorder was previously referred to as "water on the brain." Shunts for drainage may be present. (See page 83 for additional information.)

Interstitial Cystitis (IC) (physical)—Interstitial cystitis (IC) is a chronic inflammatory condition of the bladder. Symptoms include day and night frequency of urination (up to sixty times a day in severe cases) and the sensation of having to urinate immediately, which may also be accompanied by pain, pressure or spasms. Pain can occur in the lower abdominal, urethral or vaginal area. Some patients also report muscle and joint pain, migraines, allergic reactions and gastrointestinal problems. The photographer should be considerate of severe discomfort or pain and also allow for unanticipated bathroom breaks.

"Invalid"—Alternative: "Person with little or no mobility;" "not able to physically care for self." Physical immobility has nothing to do with mental capacity or ability to make decisions.

Learning Disability (LD) (cognitive)—*See* Cognitive. Refrain from giving multiple directions. Be precise and don't chatter. Discuss what will happen beforehand to lessen confusion. (See page 88 for additional information.)

Mentally Ill (MI)—Person who has a mental disorder such as bipolar condition.

"Mongoloid"—A term no longer accepted to describe the condition known as Down syndrome.

Multiple Sclerosis (MS) (physical)—MS is a disorder in which the nerves of the eye, brain and spinal cord lose patches of myelin. Symptoms generally appear in people aged 20 to 40, mostly women. Over the years, a person may lose strength or dexterity in a leg or hand. Some people develop symptoms only in the eyes.

Muscular Dystrophy (physical)—Muscular Dystrophies are a group of inherited muscle disorders that lead to muscle weakness of varying severity. Included in this condition are other inherited muscle disorders such a myotonic myopathies, glycogen storage diseases and periodic paralysis.

Obesity (physical)—Obesity is a term applied to body weight that is 20 percent or more above normal weight. The term and physical appearance can be a frequent source of embarrassment for the child. The obese child may have limited energy or mobility. Look for flattering camera angles and lighting.

Obsessive-Compulsive Disorder (OCD) (mental)—Do not underestimate the impact of this disorder on a child's behavior and a successful photo sitting. OCD is characterized by the presence of recurrent, unwanted, intrusive ideas, images or impulses that seem silly, weird, nasty or horrible to the child along with an urge or compulsion to do something that will relieve the discomfort caused by an obsession. If the child gets off track, try to redirect his or her attention to what you are doing. Repeat your directions and ask the child to provide feedback.

Osteogenesis Imperfecta (physical)—More commonly known as "brittle bones" disease, osteogenesis imperfecta is a genetic disorder characterized by bones that break easily—often from little or no apparent cause. Severity of symptoms can vary tremendously between individuals. Common features may include bones that fracture easily, hearing loss, skeletal deformities of limbs, chest and skull, scoliosis, respiratory difficulties, weak muscles, tendency to bruise easily and loose joints and ligaments.

Paraplegic (Para) (physical)—Person paralyzed in the arms or legs.

"Patient"—Someone who is currently in the care of medical professionals or a medical facility. Does not automatically describe a person with a disability.

Polio or Post-Polio Syndrome (physical)—Although polio is now rarely seen, the occasional occurrence may involve assistive devices such as breathing equipment, wheelchair or braces.

Prader Willi (mental/physical)—*See* Obesity. The child with Prader Willi disorder may have severe craving for food. These children must not be reminded of food. Therefore, don't have pictures or posters on the wall that depict it. Do not even leave empty soda cans or drink cups lying around. A vending machine could trigger difficulties.

Psychological (mental)—This is a general term and can include a wide variety of mental disorders such a schizophrenia or bipolar conditions. Try to establish rapport with the child prior to photographing. Explain the process beforehand to help avoid stress in some situations. (See page 92 for additional information.)

Quadriplegic (quad) (physical)—Person who is paralyzed in all limbs.

"Rehab"—Short for rehabilitation program.

"Retarded" or "Retard"—Neither one of these terms should be used (the latter being more offensive than the first). Instead, say "She is developmentally disabled," or "She deals with the challenge of a developmental disability." The term "mental retardation" is used in diagnoses.

Respiratory (medical and physical)—Children may have a tracheotomy tube, mask or other breathing apparatus. Take care when asking them to pose or when moving them. Some parents desire to remove the breathing apparatus temporarily. Allow the parent to use discretion in this decision, as well as manage the procedure for accomplishing this. (See page 94 for additional information.)

Rhett's Syndrome—*See* Autism.

Seizures (symptom)—*See* Epilepsy.

Spina Bifida (physical)—A condition in which part of one or more vertebrae fails to develop completely, leaving a portion of the spinal cord unprotected. This condition may be mild and corrected with surgery, but if severe requires assistance of a wheelchair.

Spinal Cord Injury (physical)—Spinal cord injuries may result in paralysis to part or parts of the body. Depending on the extent of the paralysis, the child may be confined to a wheelchair or may require a breathing apparatus or be unable to speak. If the child uses a wheelchair you may want to ask them if they can transfer (get themselves out of their chair unassisted) or if they wish to remain in their wheelchair for the session. If they need a hand in transferring, always allow the parent or attendant to assist the child.

Stimming, Selective Stimulation (symptom)—A child can begin to shake their hands, flip pieces of string or their fingers in an effort to provide pleasurable stimuli to their nervous system. This is called stimming and is evident in children with autism. Some children with cognitive or sensory disabilities may commence with this activity when fearful, anxious or nervous.

Tics (symptom)—Tics can be as minor as repetitive eye blinks or more complex as those in Tourette's syndrome where the head may move from side to side, the mouth may open wide and the neck stretches. More severe tics can include hitting and kicking, grunting, snorting and humming.

Tourette's Syndrome—Tourette's syndrome is a neurological disease characterized by symptoms which can include a lack of muscle coordination, tics and incoherent grunts and barks that may represent obscenities. Motor and vocal tics connected with this disorder can develop in early childhood, progressing to bursts of complex movements, including vocal tics and sudden, spastic breathing. A child with Tourette's syndrome may repeatedly move the head from side to side, blink the eyes, open the mouth and stretch the neck. Some hitting and kicking, grunting, snorting and humming can also occur.

Transfer—When a person is moved from a wheelchair to stationary seating or a bed.

Traumatic Brain Injury (TBI)—Traumatic brain injury can occur at birth or at any time during life as a result of an accident or other serious injury. Function and involvement varies.

"Wall-Eyed"—Do not use this pejorative term for someone with eye problems.

"Wheelchair"—It is preferable to say, "person who uses a wheelchair" instead of "wheelchair-bound" or "confined to a wheelchair."

"Victim of . . ."—Alternative: "person who deals with . . ." or "person who is challenged by . . ."

PHOTOGRAPHIC CONSIDERATIONS—QUICK REFERENCE

LIGHTING

1. Consider natural indoor or outdoor lighting for a child who is unable to adjust well to a studio.
2. Flat lighting may be your best solution for a moving child in the studio.
3. Use shadows to conceal facial abnormalities or amputation.
4. Diffused sun and filtered light will produce excellent results.
5. Some types of lighting effects, and the equipment itself, can frighten a child.
6. Flickering light could trigger a seizure.
7. New lights that emit smoke or are in the "burning off" stage could cause odors that are hazardous to children with chemical or allergic sensitivities.

CAMERA

1. Consider using a handheld camera for a child that is constantly on the move.
2. For children who are frightened of the camera, try putting it behind a type of concealment (provide an opening for the lens, of course).

TRIPOD

1. Don't plan on using a tripod unless you are certain that it is appropriate.
2. A tripod is stationary and tends to lend a static quality to your photo. The parent of a child in a wheelchair may want to see as much movement as possible their child's portrait.

FILM

1. When using natural lighting, consider using higher speed film. The grain can produce great results with action shots or props. Grain in a straight on, close-up, studio-type head shot may not produce the results you are looking for.
2. Use 1600 ISO film for acceptable results in natural light.

3. Work with the processing lab on special grain results.
4. Experiment on your own time. Be confident with the results before using a new approach with a client.
5. Consider using Polaroid positive film and special processing to produce interesting effects.

SEATING

1. Discuss seating with the parent or child prior to the session. Some parents or children may want to conceal any assistive technology—but not always.
2. If in a therapy room with many other disabled children, use a high camera angle to avoid as much equipment and tubes as possible.
3. Consider using a beanbag chair for non-ambulatory children. Ask if the parents have a transportable seating arrangement at home.
4. Alternate seating options include inflatable plastic "arm chairs" for children, the floor, a step, the arms of a sibling or parent, grandparent or friend—use your imagination and ingenuity.

POSE

1. Specific, controlled, sustained posing is most often not possible with a special needs child.
2. Instead of a formal pose, engage the child by providing something of interest to hold or look at.

DRAPE/BACKGROUND

1. Use a giant drape that can extend well over the background and floor. A child may be more comfortable on her tummy and elbows, side or back.
2. Try using section of lightweight fabric that a caregiver can hold from behind while, at the same time, providing support for the child.

ATTENTION-GETTERS

1. What works for one child with a disability may traumatize another and put an abrupt end to the sitting.
2. Ask the parent about sounds, lights, puppets or toys that might be alarming to some children.
3. When meeting the child prior to the photo session, you can experiment with various devices to get the child's attention.
4. Ask the parent about words or objects that will attract or calm the child.

PROPS

1. Children can form an attachment to certain objects such as a wooden doorstop or piece of ribbon. The parent may enjoy having a photo showing the child with his favorite giant paper clip. Do not remove these objects from the child unless the parent suggests it.
2. Some children are unable to hold certain objects or may have the inclination to propel them across the room. Your choice of props (or no props at all) can be determined in the parent interview, long before the shoot.

CHILD'S FOCUS

1. Some children avoid eye contact, others seek it. Use the parent or assistant to distract them.
2. Some children (with autism, as an example) will purposely turn their head in another direction when they see a camera or when someone talks directly to them.
3. Children with visual impairments may not have a straightforward focus. Their eyes may cross. Capture some images of them looking down or away from the camera. Eye contact is not a hard and fast rule.

AUTHOR AND CONTRIBUTORS

ABOUT THE AUTHOR

You might say that Karen Dórame has a solid photographic background—but once removed. Her mother was the avid photographer in the family, gleaning countless ribbons and medals from international salon competitions. Karen went into journalism and public relations where she used the camera in a different way. Her employment with a public health department's Office of Policy, Research and Planning provided the experience she needed to gather this book's technical information and merge it with her photographic know-how. It was the experience of her daughter Heidi with grandson Taylor at a professional photo studio that was the catalyst for initially writing the book and making this unique information available to photographers who might better serve families of children with special needs. With her daughter Heidi, Karen is a cofounder of the Picture ME Foundation and director of its Special Kids Photography program.

CONTENT DEVELOPMENT

Margaret Drda—Assistant Director, Dayle McIntosh Center for the Disabled
Sue Feller—OTR/L, PT, Latch School, Inc.
MarGreta Jorgensen—MFT
Charlotte Kies—Director of Children's Services, Rehabilitation Institute of Southern California
Nancy Molder—Principal, Latch School, Inc.
Michelle Morris—Administrator, Morris Family Home for Medically Fragile Children

Kathy Rock-Veylit—Communications Manager, Dayle McIntosh Center for the Disabled
Teri Vogeding—MS, CC-SLP, Latch School, Inc.

CONSULTATION AND CONTRIBUTIONS

Thomas Balsamo, professional photographer
Eric Benjamin, professional photographer
Sue Cassidy, professional photographer
Jennifer Collins, professional photographer
Jerry Costanzo, professional photographer
Glamour Shots
Sally Harding, professional photographer
Dina Ivory, professional photographer
Donna Leicht, professional photographer
Tim Mathiesen, Epson America, Inc.
Fred McCabe, MFT, Dayle McIntosh Center
Bryan McLellan, professional photographer
Teresa Nagy, professional photographer
The Picture People Studios
Laura Popiel, professional photographer
Janette Reynolds, Epson America, Inc.
Carolyn Sherer, professional photographer
Dan Steinhardt, Epson America, Inc.
Nancy Van Matre, photographer
Anthony Wang, professional photographer
Keith Wyner, photographer, special education teacher

INDEX

Other Books from
Amherst Media

Outdoor and Location Portrait Photography
2nd Edition
Jeff Smith

Learn how to work with natural light, select locations, and make clients look their best. Step-by-step discussions and helpful illustrations teach you the techniques you need to shoot outdoor portraits like a pro! $29.95 list, 8½x11, 128p, 60+ full-color photos, index, order no. 1632.

Posing and Lighting Techniques for Studio Photographers
J.J. Allen

Master the skills you need to create beautiful lighting for portraits of any subject. Posing techniques for flattering, classic images help turn every portrait into a work of art. $29.95 list, 8½x11, 120p, 125 full-color photos, order no. 1697.

Studio Portrait Photography of Children and Babies. *2nd Edition*
Marilyn Sholin

Learn to create images that will be treasured for years to come. Includes tips for working with kids at every developmental stage, from infant to preschooler. Features: lighting, posing and much more! $29.95 list, 8½x11, 128p, 90 full-color photos, order no. 1657.

Corrective Lighting and Posing Techniques for Portrait Photographers
Jeff Smith

Learn to make every client look his or her best by using lighting and posing to conceal real or imagined flaws—from baldness, to acne, to figure flaws. $29.95 list, 8½x11, 120p, full color, 150 photos, order no. 1711.

Fine Art Children's Photography
Doris Carol Doyle and Ian Doyle

Learn to create fine art portraits of children in black & white. Included is information on: posing, lighting for studio portraits, shooting on location, clothing selection, working with kids and parents, and much more! $29.95 list, 8½x11, 128p, 60 photos, order no. 1668.

Professional Secrets of Natural Light Portrait Photography
Douglas Allen Box

Learn to utilize natural light to create inexpensive and hassle-free portraiture. Beautifully illustrated with detailed instructions on equipment, setting selection and posing. $29.95 list, 8½x11, 128p, 80 full-color photos, order no. 1706.

Black & White Photography for 35mm
Richard Mizdal

A guide to shooting and darkroom techniques! Perfect for beginning or intermediate photographers who want to improve their skills. Features helpful illustrations and exercises to make every concept clear and easy to follow. $29.95 list, 8½x11, 128p, 100+ b&w photos, order no. 1670.

Portrait Photographer's Handbook
Bill Hurter

Bill Hurter has compiled a step-by-step guide to portraiture that easily leads the reader through all phases of portrait photography. This book will be an asset to experienced photographers and beginners alike. $29.95 list, 8½x11, 128p, full color, 60 photos, order no. 1708.

Photographing Children in Black & White
Helen T. Boursier

Learn the techniques professionals use to capture classic portraits of children (of all ages) in black & white. Discover posing, shooting, lighting and marketing techniques for black & white portraiture in the studio or on location. $29.95 list, 8½x11, 128p, 100 photos, order no. 1676.

Master Posing Guide for Portrait Photographers
J. D. Wacker

Learn the techniques you need to pose single portrait subjects, couples and groups for studio or location portraits. Includes techniques for photographing weddings, teams, children, special events and much more. $29.95 list, 8½x11, 128p, 80 photos, order no. 1722.

High Impact Portrait Photography

Lori Brystan

Learn how to create the high-end, fashion-inspired portraits your clients will love. Features posing, alternative processing and much more. $29.95 list, 8½x11, 128p, 60 full-color photos, order no. 1725.

Beginner's Guide to Adobe® Photoshop®

Michelle Perkins

Learn the skills you need to effectively make your images look their best, create original artwork or add unique effects to almost image. All topics are presented in short, easy-to-digest sections that will boost confidence and ensure outstanding images. $29.95 list, 8½x11, 128p, 150 full-color photos, order no. 1732.

Lighting Techniques for High Key Portrait Photography

Norman Phillips

From studio to location shots, this book shows readers how to meet the challenges of high key portrait photography to produce images their clients will adore. $29.95 list, 8½x11, 128p, 100 full-color photos, order no. 1736.

Photographer's Lighting Handbook

Lou Jacobs Jr.

Think you need a room full of expensive lighting equipment to get great shots? Think again. This book explains how light affects every subject you shoot and how, with a few simple techniques, you can produce the images you desire. $29.95 list, 8½x11, 128p, 130 full-color photos, order no. 1737.

Group Portrait Photographer's Handbook

Bill Hurter

With images by over twenty of the industry's top portrait photographers, this indispensible book offers timeless tips for composing, lighting and posing dynamic group portraits. $29.95 list, 8½x11, 128p, 120 full-color photos, order no. 1740.

Lighting and Exposure Techniques for Outdoor and Location Portrait Photography

J. J. Allen

The changing light and complex settings of outdoor and location shoots can be quite challenging. With the techniques found in this book, you'll learn to counterbalance these challenges with techniques that help you achieve great images every time. $29.95 list, 8½x11, 128p, 150 full-color photos, order no. 1741.

The Best of Children's Portrait Photography

Bill Hurter

See how award-winning photographers capture the magic of childhood. *Rangefinder* editor Bill Hurter draws upon the experience and work of top professional photographers, uncovering the creative and technical skills they use to create their magical portraits. $29.95 list, 8½x11, 128p, 150 full-color photos, order no. 1752.

More Photo Books Are Available

Contact us for a FREE catalog:
AMHERST MEDIA
PO BOX 586
AMHERST, NY 14226 USA

www.AmherstMedia.com

Ordering & Sales Information:

INDIVIDUALS: If possible, purchase books from an Amherst Media retailer. Write to us for the dealer nearest you. To order direct, send a check or money order with a note listing the books you want and your shipping address. For domestic and international shipping charges, visit our web site, or call/fax the number below. Visa and MasterCard accepted. New York state residents add 8% sales tax.

DEALERS, DISTRIBUTORS & COLLEGES: Write, call or fax to place orders. For price information, contact Amherst Media or an Amherst Media sales representative. Net 30 days.

1(800)622-3278 or (716)874-4450
FAX: (716)874-4508

All prices, publication dates, and specifications are subject to change without notice.

Prices are in U.S. dollars. Payment in U.S. funds only.